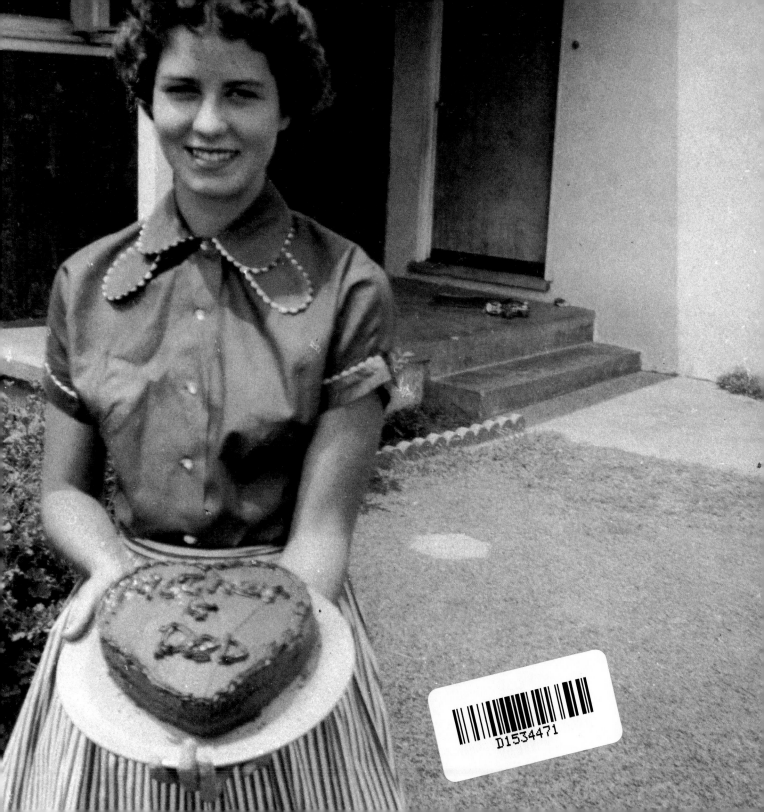

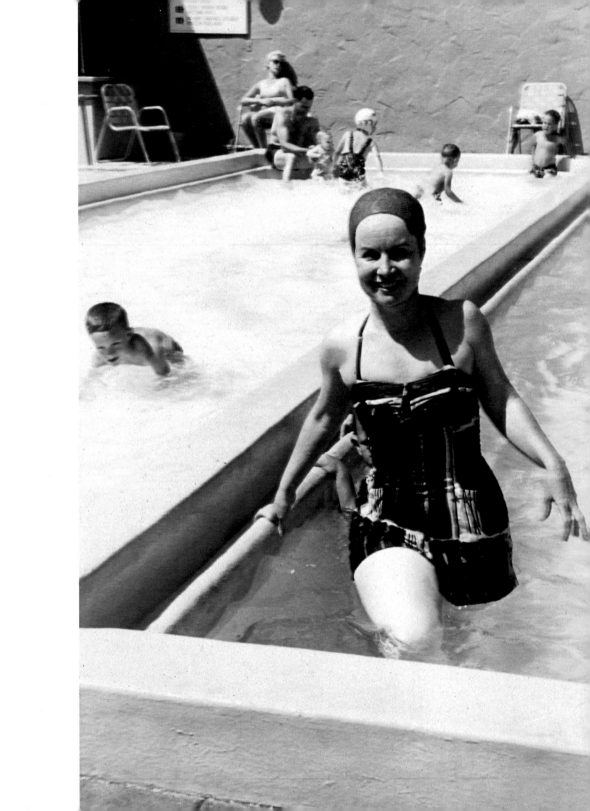

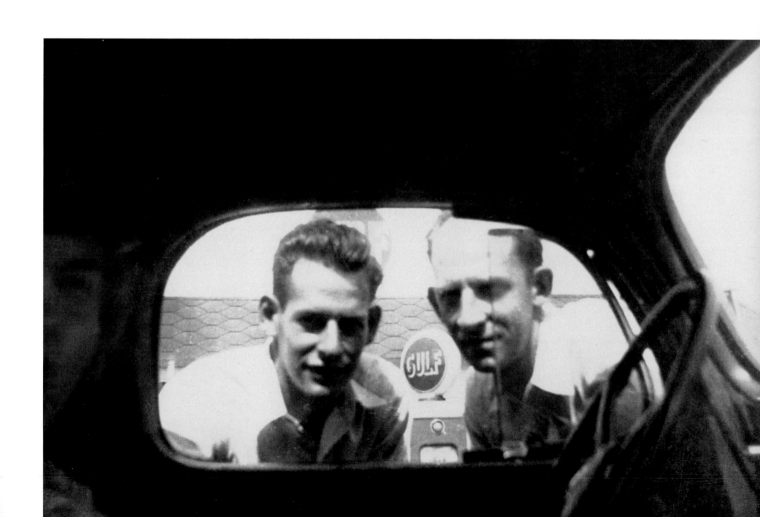

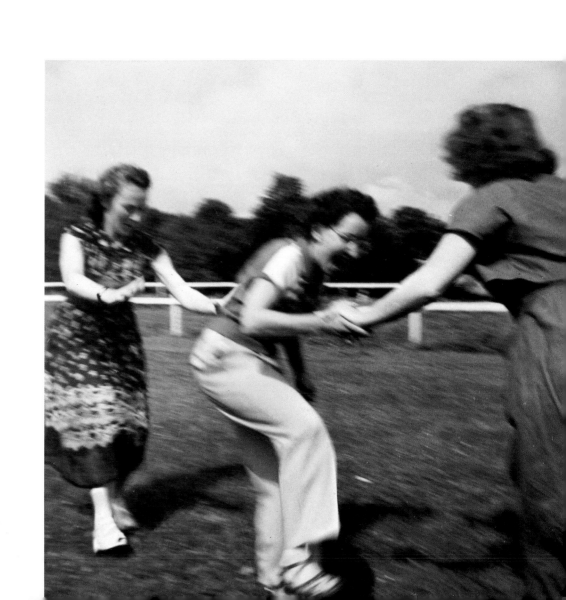

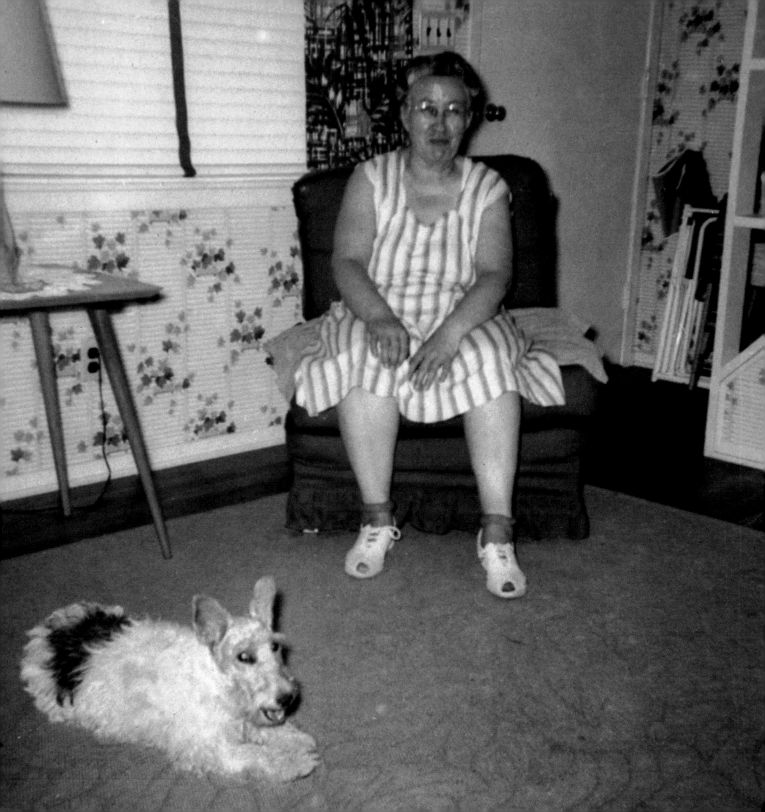

Close to Home
An American Album

With an essay by D. J. Waldie

THE J. PAUL GETTY MUSEUM, LOS ANGELES

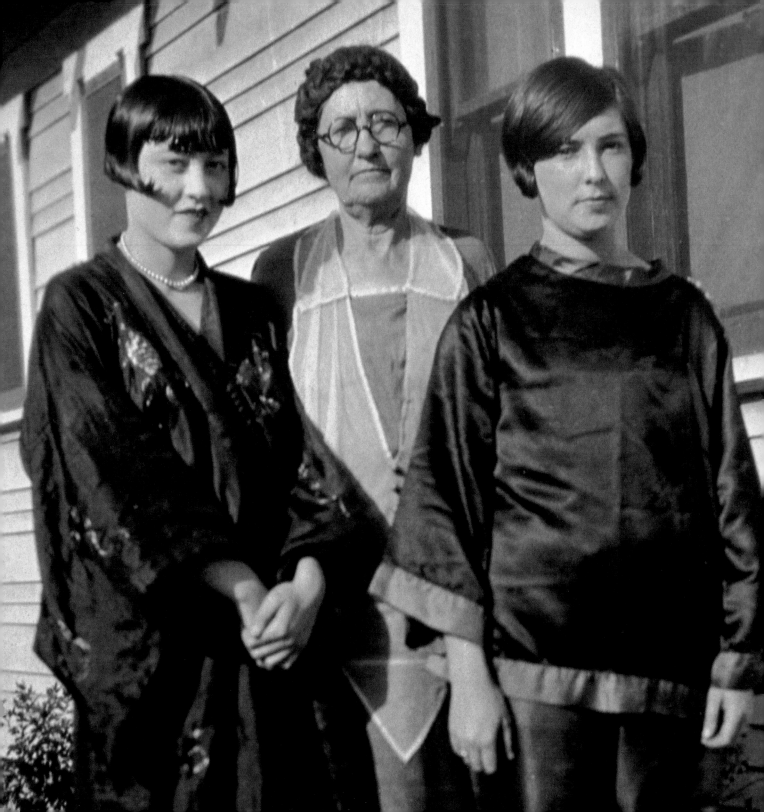

Contents

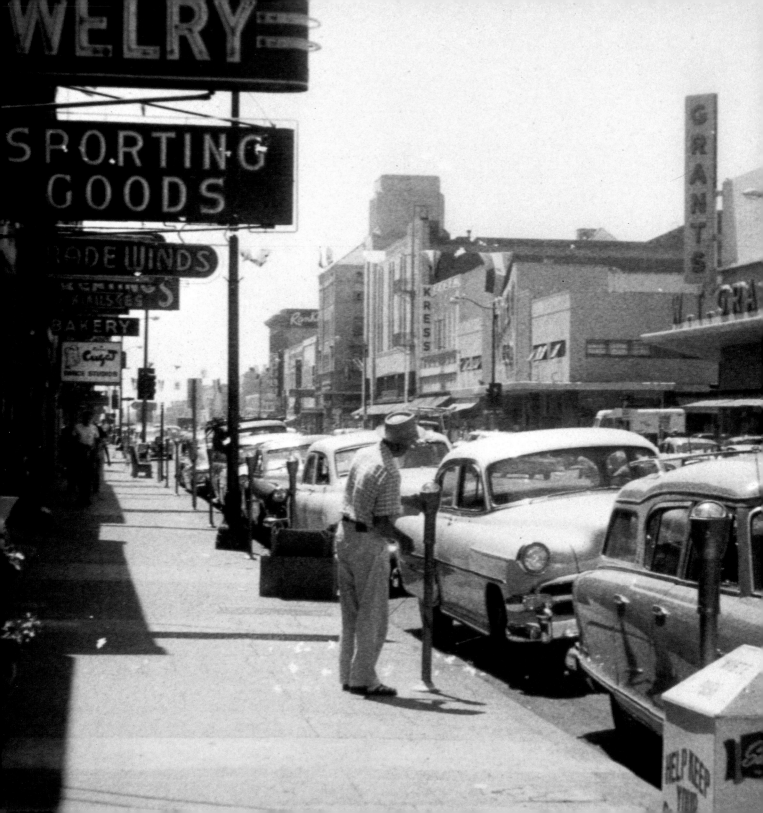

Foreword

WHEN IT COMES TO PHOTOGRAPHS, the Getty Museum, like most other art museums, has traditionally concentrated on work created by known, often famous, makers. Although our collection comprises a great number of photographs by anonymous practitioners, these works are less often the subject of exhibitions and publications. Over the past twenty years, first at the Getty Villa in Malibu and now at the Getty Center, we have produced thirty publications and presented more than seventy exhibitions, only two of which incorporated a significant number of photographs by unknown makers. They were *Little Pictures* (December 7, 1993–March 6, 1994) and *Hidden Witness: African Americans in Early Photography* (February 28–June 18, 1995), both of which consisted largely of photographs made before 1900. With *Close to Home: An American Album*, the thread is followed to the mid-twentieth century and beyond.

We are grateful to the collectors and artists who have brought us into another aesthetic universe completely, one the Getty Museum has not visited before: that of the snapshot. The collectors—Nancy and Bruce Berman, Sharon and Michael Blasgen, and Jane and Michael Wilson—worked with passionate, well-informed teams who encouraged their interests in the subject. The Bermans collaborated with art dealer Rose Shoshana and printers Irene Malli and Guy Stricherz. The Blasgens and the Wilsons collaborated with Gail Pine and Jacqueline Woods, who are artists, writers, and collectors; they also benefited from the energetic efforts of writer Babbette Hines, artist Norman Kulkin, and actor Mitch Longley.

I am grateful to Paul Martineau, Curatorial Assistant, and Weston Naef, Curator of Photographs, who are to be congratulated for taking our collection in this new direction, presenting us with these oddly touching images whose only real function—as D. J. Waldie says in his illuminating essay—is to cherish the thing photographed.

Deborah Gribbon
Director, J. Paul Getty Museum
Vice President, J. Paul Getty Trust

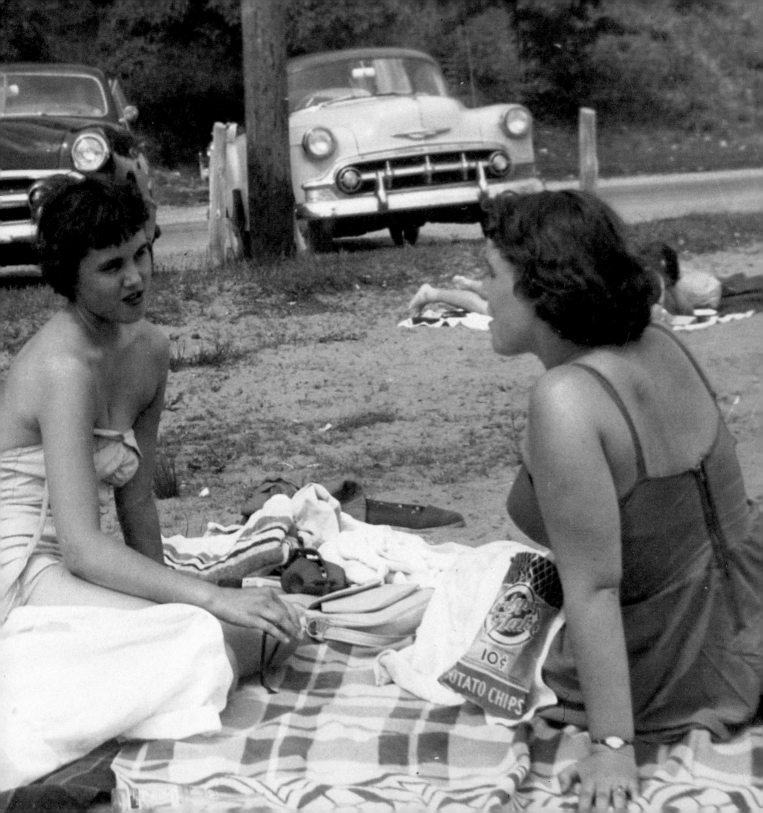

Preface

IF ALL HUMAN EXISTENCE is essentially social, then snapshot photography has become the chief visual instrument of social memory. This book, like the exhibition it accompanies, is grounded in this precept, brought to the fore by a small group of artists, writers, and collectors, all of whom have been engaged in translating the meaning of these images as well as giving them sanctuary.

As a curator of photographs, I began to recognize the profound gulf between the kind of photographs usually collected by art museums and amateur photography. Snapshots, which were often separated from their owners and then rediscovered by others, presented a mystery to be solved.

In the 1990s I started to discover that I was not alone in my interest in these photographs. Artist-collector-dealers Gail Pine, Jacqueline Woods, and Norman Kulkin; as well as actor Mitch Longley; writer Babbette Hines; collectors Bruce Berman, Michael Blasgen, and Michael Wilson; and the husband-and-wife fine-art printing team of Guy Stricherz and Irene Malli began to collect snapshots by amateur photographers. For the most part, these photographs were originally found in outdoor markets and secondhand shops. The process of gathering and selecting individual images for the book and exhibition was a truly joint effort on the part of the artists, collectors, and museum curator. We were drawn to the particular images shown here because each picture raised the question, Why was this photograph made?

The important role of artists and writers as hoarders and exploiters of snapshot imagery is not surprising, as artists are often instrumental in the process of discovering meaning in lost, abandoned, and overlooked artifacts in search of the raw material of art. "I am drawn to snapshots because an unknown past, the living present of the picture itself, and an unknown future that occurred after the picture was made compel me to silently speculate on the unknowns," Woods commented.

Artists are also governed by imagination, which is liberated from the constraints of conventional thinking. Pine's interest in snapshots, for example, was born out of the loss of her father and through him the loss of a large part of her own familial photo history. "In some ways my collecting creates a new family for me to replace the bro-

ken one, complete with their own strengths, imperfections, and idiosyncrasies. In every picture of a man standing hands-in-pockets I search for the image of my lost father, who took many of the pictures with him," she reflected.

Likewise, artists are often the first to explore uncharted visual terrain. Kulkin, an artist as well as a collector and dealer in found photographs, recalled while studying his own family photographs how he collapsed his own childhood recollections with pictures of actual events that had taken place before his birth and at times and places he never witnessed, as if the memories were the result of his own firsthand experience. This phenomenon causes us to contemplate the central feature of memory, which is that *experiences alter subsequent experience and behavior.*

The familiar adage that truth is stranger than fiction is played out in these pictures, all of which were inspired by actual lives once lived. "You cannot invent the truth," Hines remarked, to which collector and engineer Michael Blasgen countered, "Every photograph is a lie, for in fact time does not stand still." Yet a photograph is a real object that suspends a vivid moment in time, traps it in light-sensitive materials and fixes it indefinitely for another to view and experience.

This book and the exhibition it accompanies fall into two historical categories. The mostly black-and-white photographs on pages 1–101 were found in outdoor markets and secondhand shops, while those on pages 103–117, all of which were reproduced from Kodachrome color transparencies, were secured from their makers or descendants. With a handful of exceptions, the black-and-white photographs had been abandoned. The photographers and their subjects were, for the most part, anonymous, the images purely visual experiences with no need for explanatory captions. The color slides came from their owners, the photographers and their subjects known. The slides were then re-created by Stricherz and Malli in the form of exquisite dye transfer exhibition prints.

The most common way in which the content of pictures is conveyed is through words. However, words alone often fail to describe and decipher the full meaning of snapshots. We must rely, then, on the eyes in concert with the heart for their emotional meaning to be revealed.

Though devoid of written explanation, these pictures clearly reveal events in the timelines of individual histories—from the experience of being single to bonding in couples or groups, the genesis of family, the experience of travel, the cultivation of material desires and pride of ownership. The pictures unfold in a chronicle of repeated experiences, the script of life that invariably begins "close to home": men standing alone, observed by their wives, mothers, or friends; women standing alone, observed by husbands or lovers; girlfriends and pals posing together, as well as couples indoors and out. These artifacts of people's lives reveal a shared desire to document their houses, cars, and fashions as emblems of identity.

All human beings search for meaning in their lives and experiences, and all observers of snapshots bring their own histories to the creation of meaning. Every person who turns the pages of this book will have a different reason for stopping to gaze at one image or another, yet all will be able to relate their own personal experiences to the content of the pictures that draw them in. The social fuel of snapshots resides in their abundance, not their rarity; and their vast quantity expresses the collective social experience of postindustrial American society.

Not every snapshot is a masterpiece, but some are more emblematic of the collective experience than others, and some are better crafted or better preserved, thus enhancing their cultural and historical importance. Quality and value in a snapshot are measured by the accuracy with which they reflect our collective social conscience as well as by their potential to connect each of us as individuals and by their power to spur our empathy.

Weston Naef
Curator of Photographs
J. Paul Getty Museum

Facing the Facts

D. J. Waldie

Everything's mine but just on loan,
nothing for the memory to hold,
though mine as long as I look.

— Wislawa Szymborska

REMEMBER? You were young then and holding a little paper rectangle as crisp as a playing card, its surface like glass, and behind it, the diminished figure of someone posing for a picture. Then a woman's hand, far older than yours, passed you another snapshot. "This is my aunt and here is her husband," she said. "You never met them because they lived back east." (Everyone you never met lived there; you thought "back east" must have been a place filled with abandoned, disoriented people.)

"And let me tell you their story," she continued, and she does, but it's only a fragment. Because here is your father, in a different time and place, in his Army uniform when he went to into the war, but that's only a fragment of another story. Because here you are when you were three, not so long ago and in another place, but your own story is only a fragment to you, too. Because here is another snapshot and another story. (Montage didn't begin at the movies; it began with the family album.)

Then one day, years later, the one member of your family dies who knew how to piece these fragments together. Why did she hold all these stories, just as the shoeboxes held their snapshots? Why didn't anyone else hold them? Then your father dies; his wartime buddies, lean and young in their snapshots, die a second death from forgetfulness. Then your mother dies; her wedding pictures are crowded with lovely bridesmaids and a grim minister unremembered long before. But the snapshots inexplicably remain, poised between hands, like a magician's levitating card trick.

You put the shoeboxes of snapshots in the garage, thinking, you don't know any of these people; you never knew any of these people. But dimly, here's a face that seems familiar, and another one. Is that your mother's cousin, looking serious, the one who loved her like a sister, didn't someone once say? Is that your father's boss, smiling broadly for no reason, whose son died in Vietnam? Still later, you took the shoeboxes to a self-storage place at the edge of the bad part of town because you've got so much stuff here at the house and the garage is full already, but you couldn't throw these snapshots away. You want to turn them over to the kids, but you discover you don't have kids or they won't have you, and then you have other things to think about, now that you're dead.

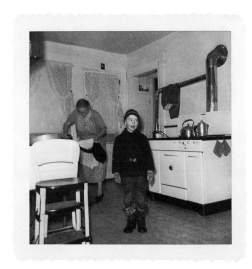

And a few months later, because you've passed beyond caring and paying the rent, a man you never met (from back east, perhaps) takes everything out of the storage unit where the shackle of the padlock has just been cut, and he puts the boxes in the back of a shabby pickup or a van with patches of gray primer paint on the door and he takes them to the Saturday swap meet at a rundown drive-in movie theater, and some of the shoeboxes full of snapshots split and spill the pictures out and the guy who bought the boxes leaves them there all day without looking at them.

He'll throw your snapshots in the dumpster next to the snack bar before he packs up and leaves.

But standing in front of his stall, someone you'll never meet reaches down and picks up a glossy rectangle of black and white and stares into it like a Peeping Tom gazing for pleasure into an empty room. Your lost snapshots have been found.

Is this the fate you would have chosen for them (if you could choose anything from your place of eternal repose)? Would you have your snapshots gathered at the entrance to the incinerator of history, stripped of their associations, and selected, this one to be kept for now by a knowing stranger for reasons you'd find puzzling and possibly sad, and those others—perhaps the very ones that once evoked the purest memories—to be lost forever?

When they were in the air between old hands and your hands, your snapshots weren't ironic. They didn't anthropologize. They didn't want much more than what was told about them. They didn't congratulate the photographer who took them or the one who gazed at them. Your snapshots had only one aspiration: to be handed around. They had only one purpose: to incite stories. They had the power to appropriate and alienate—and they did—but they only intended to cherish.

Photography, as the first modern art (that is, the first to give science greater weight than aesthetics), had promised more. Photography had promised to bring back hard evidence from a world of facts, but it delivered more conjecture. *This is the way things are*, a photograph insists, but we know by now that it's only the way some-

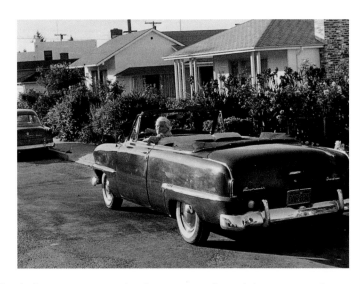

thing was, and only for an instant and only in one preferred direction, without reference to what was off to the side, or to the moment before, or any of the many moments that followed.

Photography had promised to romanticize everyday life, too, but the democratically simple Kodak camera of 1888, and the ever cheaper and simpler cameras that followed, rained hundreds of millions of casual snapshots over the nineteenth-century's uplifting assumptions. Once, photographers and their subjects had been separated in a hierarchy of taste and knowledge. Then the Kodak System ("You press the button, we do the rest") collapsed picture taker, subject, and consumer into one—a twitchy, indiscriminate shutterbug who, from childhood on, knew how to take a snapshot and be seen in one.

Point-and-shoot technology built into the mechanism of the camera, and even into the film stock and commercial printing process, assures every amateur today of being an adequate technician of the photographic image. The sparse vocabulary of gesture in a snapshot, recalled at the moment when everyone in the viewfinder shifts into a pose at the command of the picture taker, means that almost every picture has the same public surface.

Photography's document and romance have become the incident and sentiment of our "Kodak culture."

This culture, like all cultures, inevitably produces clichés. Vacationers pose with their back to the sight they are supposed to be seeing. Major celebrations are always recorded as tableaus of family relationships; very few friends or colleagues make the cut. Moody children and exuberant adults are always moody or exuberant; they never break character before the camera. Self-conscious jokes re-create the compositional pratfalls of naïve snapshots, except no one is naïve anymore. More women and children are pictured; men are behind the camera, calling the shots. The first child is photographed more than the next and, according to studies of family albums, is the only one who will be shown being fed. Snapshot shooters never take pictures of family arguments, abuse by spouses or parents, the deteriorations of sickness and disability, or the facts of solitude or death.

(Today's picture takers are so squeamish. During the nineteenth century, studio photographers often photographed dead children, lying as if asleep in a cradle but more often being held in their mother's arms, sometimes

posed with other children in the family. In Austria, so many parents went to photo studios with dead children that the authorities declared a public health threat and prohibited the practice.)

Snapshot shooters sidestep more than just troubling content. In older photographs, the subjects look glummer, partly, of course, because of long exposure times, but also, perhaps, because they were closer to an era when facts didn't come with so much cheerful spin. The faces mostly smile in recent snapshots—like archaic Greek kouroi or the figures of husbands and wives from Egypt's Old Kingdom tombs—because the subjects are aware that their photograph is the projection of an image as much as it's the preservation of a fact.

Today, photographer and subject, becoming each other as they hand the disposable camera back and forth, have thoroughly internalized snapshot clichés. They've already seen the picture they've just taken. It's been parodied in magazine advertisements, accompanied a TV newscaster's announcement of a killing, appeared inside a supermarket tabloid, illustrated a dictator's biography, hung in museum galleries, been found wedged between the pages of a library book, and been pasted into an album lying in a funeral home next to the casket of a distant relative.

The next snapshot they're about to take is everywhere, too. Everyone makes them. Everyone's in them. Everyone wants to be remembered. Almost everyone wants to remember, but there are so many different pasts: the past in private reverie, in family fable, and in public history. Pick up one of your snapshots, even one that you only half remember, and all of these pasts push forward, trying to bring the image to life.

It's the work of a moment to chuck out or incinerate a single snapshot or a lifetime of them when one of these pasts is no longer wanted. The standard black-and-white print of 1950, with its filigreed edge, rips after a slight resistance; self-inflicted amnesia couldn't be more satisfying. It's a wonder that so many snapshots have survived as stubborn things; some have held on for a hundred years. But it's problematic that they'll survive as the vernacular of memory much longer. "Kodak culture" has gone digital, and the uses of the digital snapshot—as an attachment to an e-mail or a tiny square on a cell-phone screen—serve our purposes less than they do "the accel-

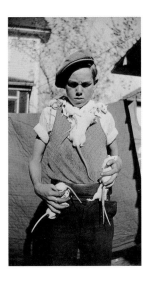

eration of history," Henry Adams's baleful insight in 1908 that, in the name of quickening modernity, we're bound to be barbarians to ourselves. Few digital snapshots make it to a hard drive, even fewer to a printer; almost none will have anything like the durability of the drugstore print of sixty years ago.

By leaving fewer tangible traces to provoke a story, our past is becoming the past ever faster. To gain even more speed, we lighten ourselves of the snapshots by which we remember, especially when the substance of memory is so commonplace, so unflattering, even as it strives to put on its best face, and so much in need of us.

What's thrown overboard in the regime of speed is mostly sucked under and lost. But some of it washes up on a distant, asphalt shore.

You survived because you were the first.
You survived because you were the last.
Because alone. Because the others.
Because on the left. Because on the right.
Because it was raining. Because it was sunny.
Because a shadow fell.

— Wislawa Szymborska

Randy Burger is a friend who, on weekends, combs a swap meet in a community-college parking lot on the fringe of a sea of suburban tracts. It's the sort of swap meet where you find working-class vendors selling to the working poor, even though it's in affluent Orange County, California. Professional dealers in the things auctioned from storage units come, too. They lay out the stuff sifting downward in the gray economy that processes the abandoned bits of everyday life after the obviously valuable and usefully secondhand and minimally collectible are mostly, but not entirely, gleaned for a profit. At the bottom, my friend says, are the family snapshots.

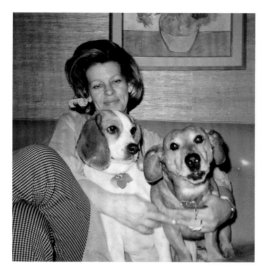

He isn't looking for lost photographs—he calls them "orphaned"—but he sees a lot of them anyway. "I saw an album," he tells me, "that was filled with old photographs and it was carefully annotated, including genealogies." (A whole tribe is obliterated.) He says that photographs still in frames are sold for the value of the frame. Loose snapshots sell for next to nothing; he's seen vendors give them away. A surprising number of these are recent snapshots of African Americans and Latinos. Memory is sometimes an unaffordable luxury.

"I can only hope that the moment when one of these photos was taken was a moment filled with genuine feeling," he says, "and that the photo and what it represented were cherished and understood by someone," even if was only for a little while before ending at the swap meet.

He sees his future there. "I don't know all the people in my own photographs—relatives or friends of my parents who stand around smiling in front of houses, in front of cars, and in front of tractors," he says. "What I do know probably won't last another generation. Not only can I see the faces of my relatives one day looking up at someone at that swap meet, but I can see my own face frozen in time on the asphalt of that parking lot."

My friend sees memento mori littering a swap meet space, and he grieves over what he expects to be. "You and I saw a tombstone years ago in Quebec City," he reminds me. "*Ne m'oubliez pas*, it said. 'Don't forget me.'"

The commandment to remember leads some to collect and publish their found snapshots as acts of resistance against official amnesia. At Susan Meiselas's Web site, stateless Kurds are asked to identify a growing collection of anonymous snapshots to "build a collective memory," she says, for "a people who have no national archive."

Ann Weiss found the photographs of an even more monstrous forgetting. She walked into a neglected storeroom at Auschwitz-Birkenau in 1986 and found nearly three thousand snapshots collected in 1943 by Nazi guards from a trainload of Jewish prisoners. Lest any fact of their life outlive their death, the snapshots that prisoners concealed were searched out and routinely destroyed, except for these few that escaped destruction and were confiscated by the camp's Red Army liberators, kept for no apparent purpose, and returned to Auschwitz-Birkenau only to be forgotten again. Weiss has spent years restoring names and genealogies to her found snap-

shots, giving stories to mundane pictures of weddings, birthdays, summer outings, sober people holding babies, businessmen in suits, and smiling women in hats.

By what they chose to remember, these men and women have restored to them a life uncontaminated by the terrible abstraction of their death. This is the heroism of snapshots: in the right hands, they stand against even the evil of enforced forgetting.

And if no one wants to remember, if no one discovers in them a reminder of a burden that cannot be put down, and if they aren't dumped by the end of the day, and if they fall into avid hands by chance, then the lost snapshots found at the swap meet become objects of fascination. "My personal reaction is different each time I find some," Ann Colvin, a collector, tells me. "They catch my eye, the time period mostly, then I just get lost in the 'looking.' The photographs always have stories. Some are obvious, like old wedding photographs or events in a family's life, and some are hidden in the photography itself. Those I find most interesting, and they draw me into them. Again, I find myself lost in the image. I believe they can become almost magic."

Colvin hangs her magical snapshots where her friends and family members see them and ask about them. Other collectors assemble their found snapshots in online galleries where the viewer's speculation is invited. This is mostly comedy with ironic captions, but sometimes a found snapshot illuminates a memory and fulfills its purpose as the pretext to a story, even if the story isn't the snapshot's own.

Gail Pine and Jacqueline Woods—California artists who are custodians of thousands of photographs rescued from swap meets, including many in this book—tap into this mystery. "Memory, an intangible, seems almost a tangible thing," they assure me, "when gazing into a snapshot. Suddenly smells, sounds, and sometimes even tastes bump us right in the memory bone. The 'Then' becomes 'Now,' just for a second."

Found photographs are elusive, vulnerable, ominous, and ordinary, part historical diorama and part freak show. Mutely, they've passed through hazards to be selected, each with its own practical, moral, and aesthetic questions: Why was that subject photographed and that snapshot printed and that one saved? Why was this

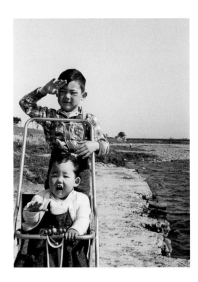

snapshot picked up before others were thrown away, that one chosen later to be kept when others weren't? And—for a very few—why were these snapshots delivered to the museum curator, and why did some of those make the cut and get on the gallery wall?

I don't know. All I know is how to look. All I see is how one photographer once saw. The longer I look, the more the snapshot in my hand becomes anything I want to make of it.

Maybe this particular photograph is folk art. The nicely dressed man and women displaying a birthday cake, the boy padded with rats, the woman dressed as a die, and the man in the "Groucho" glasses and mustache insist on the validity of their representation of themselves. "I made this of me," they might be saying. "For my own purposes."

Or maybe this photograph is something else entirely. The simple drugstore print buckles under the weight of interpretation even as I begin to understand that the interpretive impulse is all that I have in the face of the snapshot's obdurate presence. Found snapshots may look like fragments of a narrative to be decoded, but the formal grids I lay over them never stick.

Maybe found snapshots are just uncanny: an American-brand surreality of domesticated weirdness plucked by the disembodied wit of modernity from the chaos of the images we've made of ourselves. The very tall man and the very short woman dance on the lawn. The two women grimace while another looks on. The car enters the car wash. The nearly empty refrigerator gapes to reveal a can of V-8. The woman in undergarments and stockings hoists a double highball glass. The woman in a bikini holds a dead rabbit and a rifle. The woman in the sunsuit does a stock pinup pose under a sign that reads "PRIVATE." The baby holds a picture of a soldier.

All I do is look. I'm a voyeur, a stranger who should never have been left alone to thumb through the family album and become fascinated with intimacies that were not meant for me.

The couple in the embrace of the light that hovers over them is smiling so calmly that I want to be their son. His right hand on the back of her upholstered chair is the promise of a touch. If the radio begins playing some-

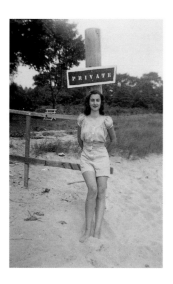

thing sentimental, he might complete his half-turn around the lamp, lean on the wide arm of her chair, and give the matronly woman—her smile is more knowing, now that I think about it—a young man's kiss.

The voyeur's pleasure is your exposure to his daydream and his concealment from you. Putting snapshots in the museum validates and regulates my eager looking-from-a-distance at the photographs' social nakedness. Although the intimate moments are curiously dispassionate and everything in the image is on the surface and it requires my effort to fill in a story that's funny or tragic or ordinary, the found snapshot on display in "the context of no context" on the white gallery wall gains for me unintended erotic attraction.

In traveling from closet to museum, snapshots shed their role as instigators of domestic history—always partial and subject to revision—and became, for their viewers, objects of wonder or harmless prurience. For photographers, they became a source catalogue for an accidental "snapshot aesthetic" of the irrelevant and unintelligible details that dominate a photograph when the narrative of everyday life is stopped with a click. In the "authored" photography in the 1970s and 1980s, the snapshot's mixture of contrivance and vulnerability lent a fleeting authenticity to the carefully crafted photographs in museum shows and magazine spreads. "Look at this moment," invented snapshots said, "but you miss the point if you regard us too long or too seriously. And remember to look ironically."

Museum curators, the official custodians of what we look at, have hung both found and made-up snapshots next to crime scene photos, stills from industrial films, old pornography, institutional mug shots, accident investigation records, and advertising photography. They used snapshots, among other ambiguous objects in the 1980s, to make a new kind of museum out of the deconsecrated space that was left after the passing of modernism.

The swarm of ambivalent meanings in found snapshots (and other anonymous or almost anonymous photography) has conveniently answered everyone's needs, from commodity to fetish to consolation.

Memory at last has what it sought.

— Wislawa Szymborska

Found snapshots serve the memory of modernism with their artless gestures toward the broken themes of the old avant-garde. That makes them chilling fun when they're at the safe distance of a gallery wall or the pages of a coffee-table book. But what demand is made by the hunger of memory in them?

It might be compassion. Snapshots litter the contested ground between candor and concealment, between what's public and what's private in families. Imagine everyone gathered around the family photo album. The snapshot in view, depending on who's doing the looking, is horrifying, hilarious, pointless, or suffused with yearning. What a snapshot wants to have leak out of its neat rectangle is the messy network of human relationships for which the snapshot was made.

Or the hunger might be fear. All of us are arsonists, and the ordinary is on fire every day. These snapshots—those you've just found and your own that you're about to lose—insist that we're destined to be among the disappeared. The flimsy snapshot is the last artifact that will remember your likeness, your preferences, and your unavailing self-regard. What a snapshot fears isn't its destruction but your anonymity.

"We are poor passing facts," wrote Robert Lowell, "warned by that to give / each figure in the photograph / his living name." It's tenderness, then, for which your snapshots long. It's not just the faces in a snapshot that appeal for a caress that cannot be reciprocated. Everything in the snapshot wants it, and all the much-handled things you grew up with want it, too. "Fall in love again," your snapshots say, "with what you already have."

Or these snapshots might need your forgiveness. Grievances crowd them, even the snapshots that aren't yours. Either they fail to satisfy your present desires and leave you with fury and contempt, or they record desires you no longer want. Found snapshots are mostly the debris of consumption. That does not make them less in need of you. In fact, the more worn and undecipherable the image, the more it resists our easy dismissal, and the

more it insists that its references be puzzled out, its story be imagined into existence. The purpose in a found snapshot is, I suppose, to teach you pity and give you a human heart.

Or it's just to persist. The commonplace, the place where we find love and hope, necessarily disappears without murmur or complaint; it's only remembered. The snapshots I hold resist my preference for forgetfulness.

We're like snapshots. What we hunger for is remembrance. Found snapshots are trivial, but they're bodies, too, just like you and me, and they have nowhere else to go but into someone's hands or into the furnace. You are seeing. They are seen. That's all the faith they need. Just look. You were lost, but now your snapshots have found you.

Close to Home: An American Album

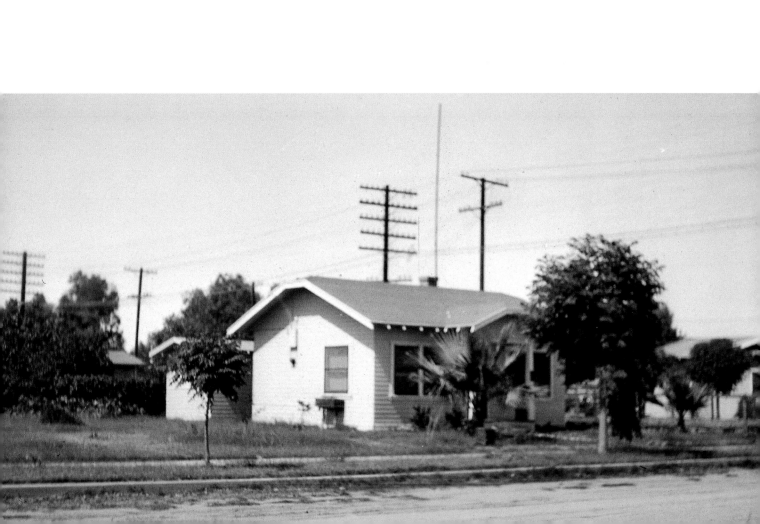

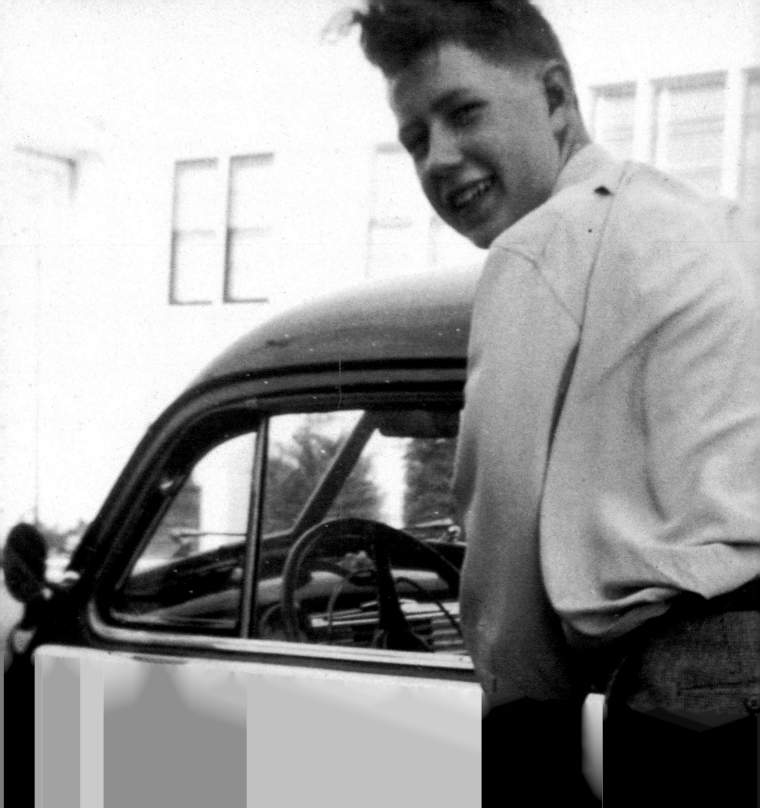

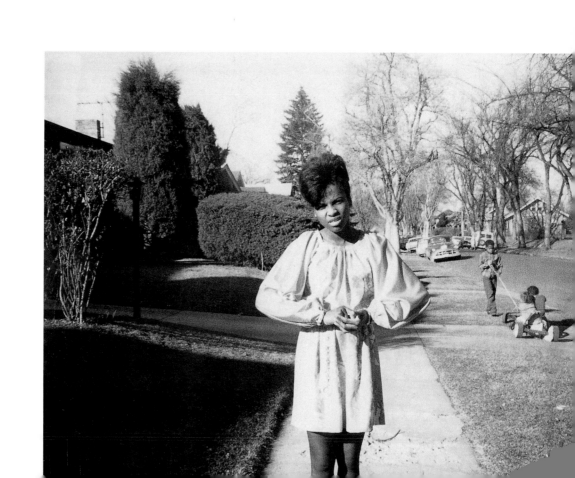

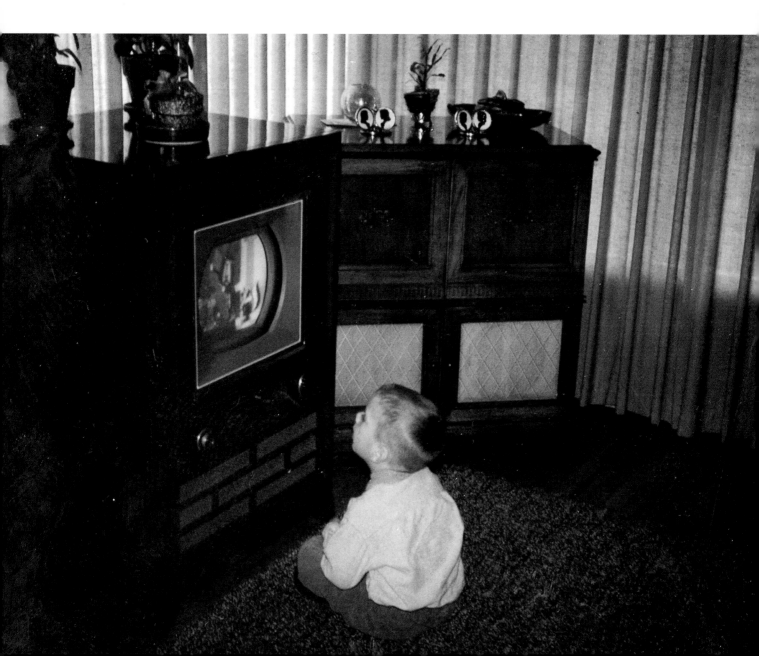

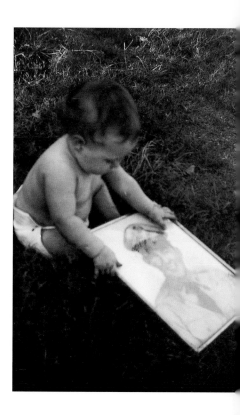

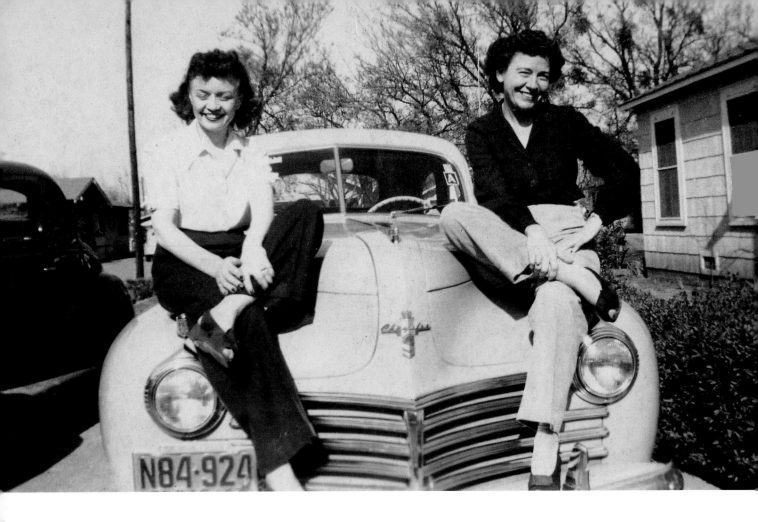

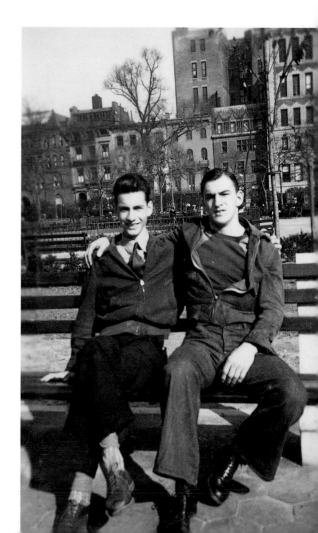

27

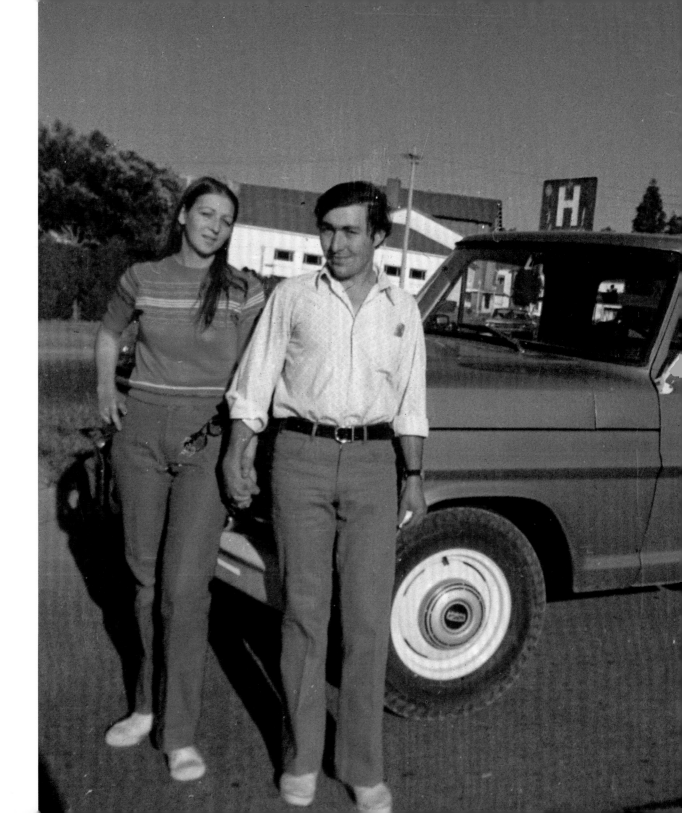

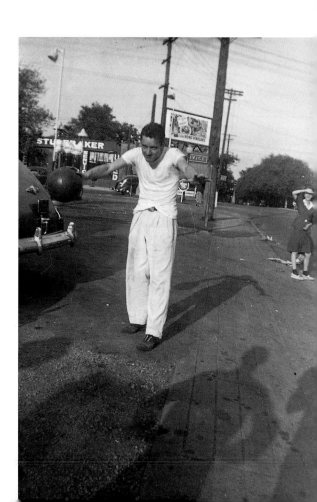

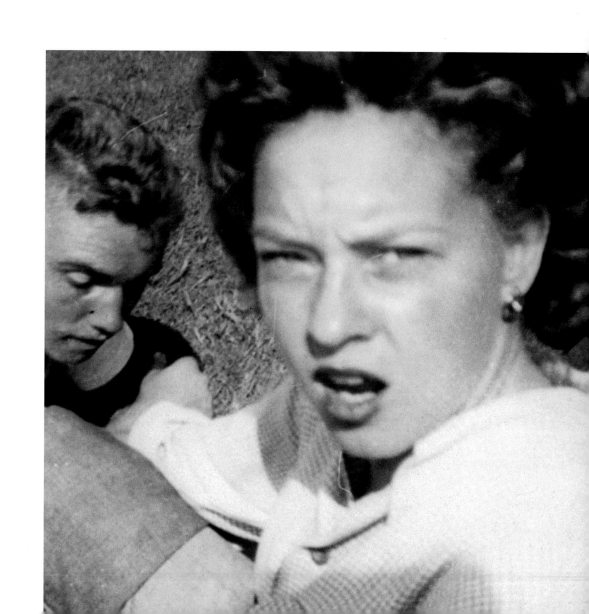

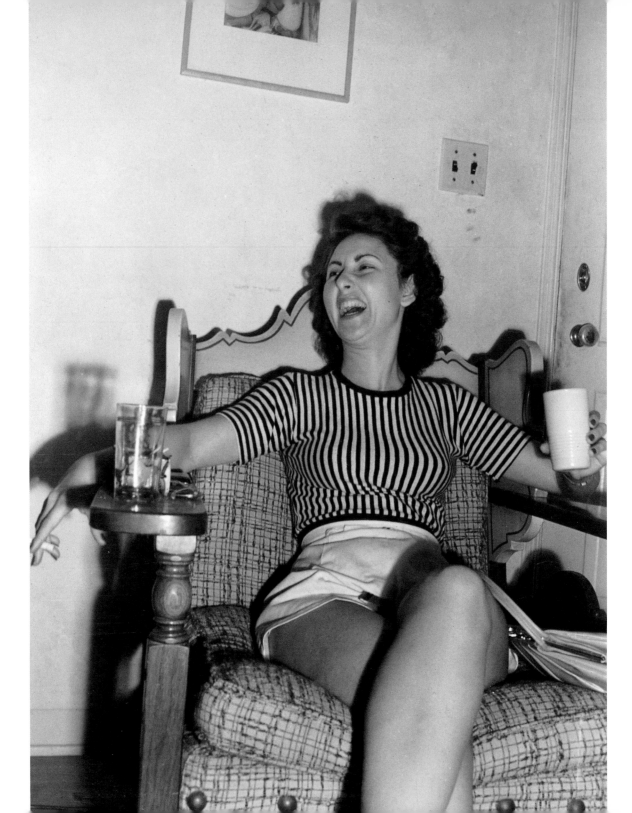

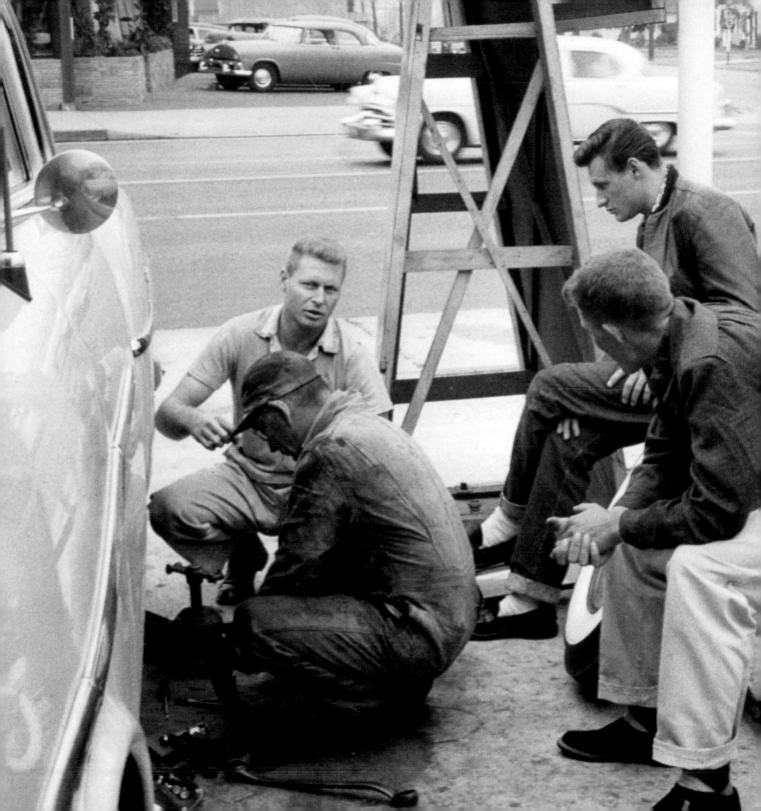

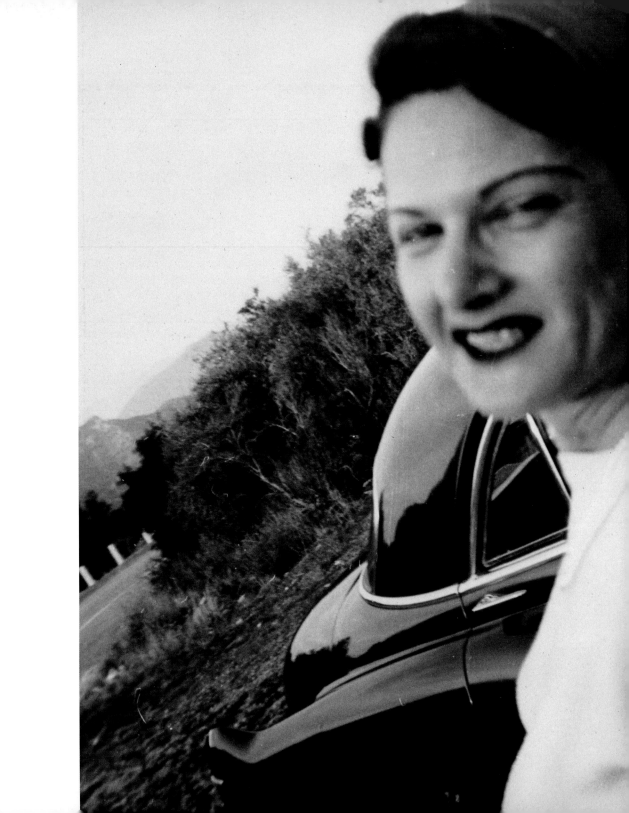

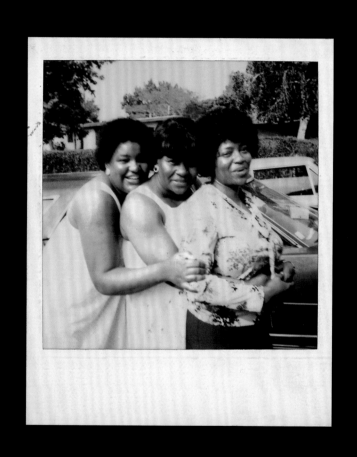

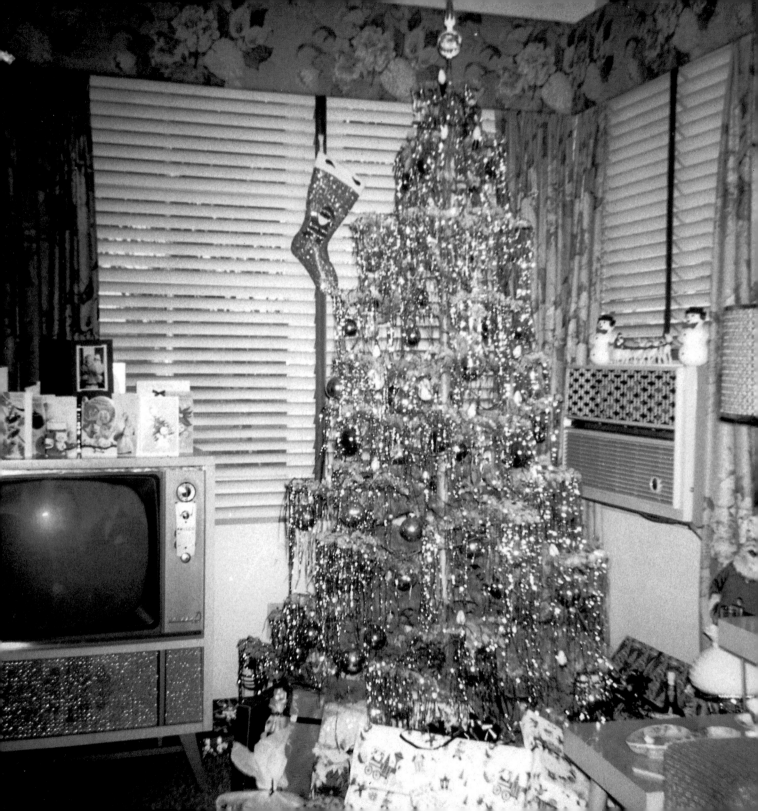

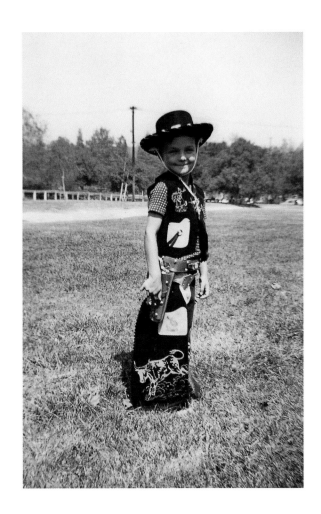

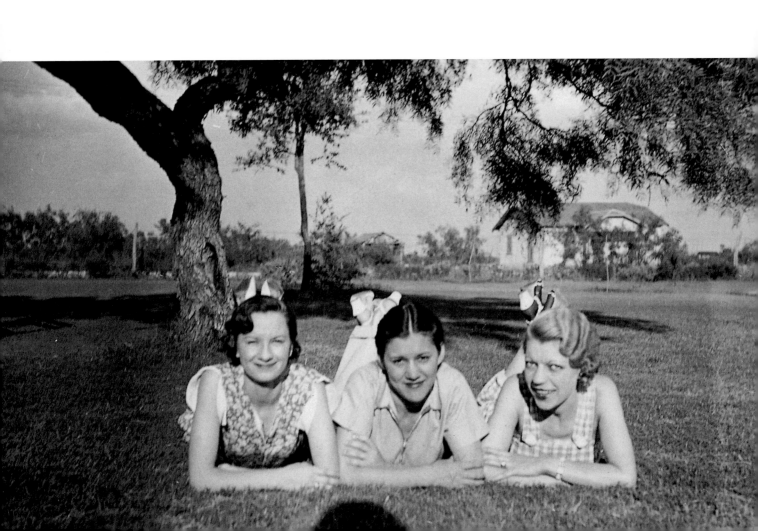

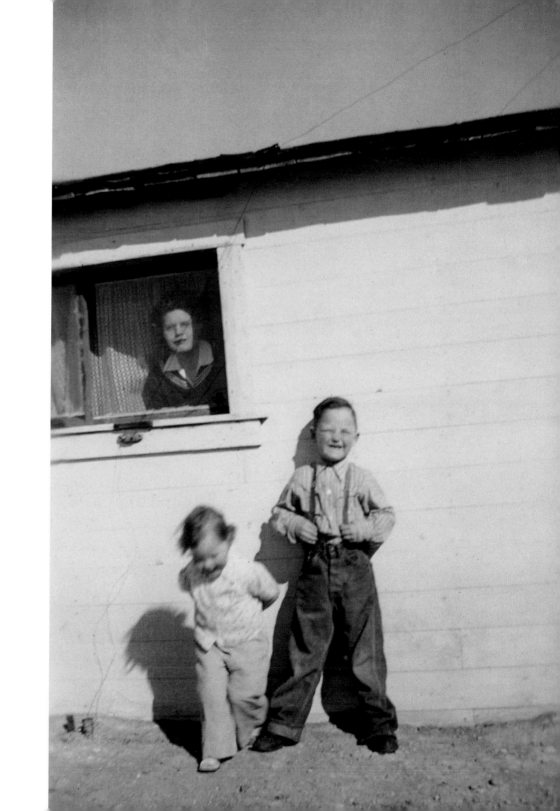

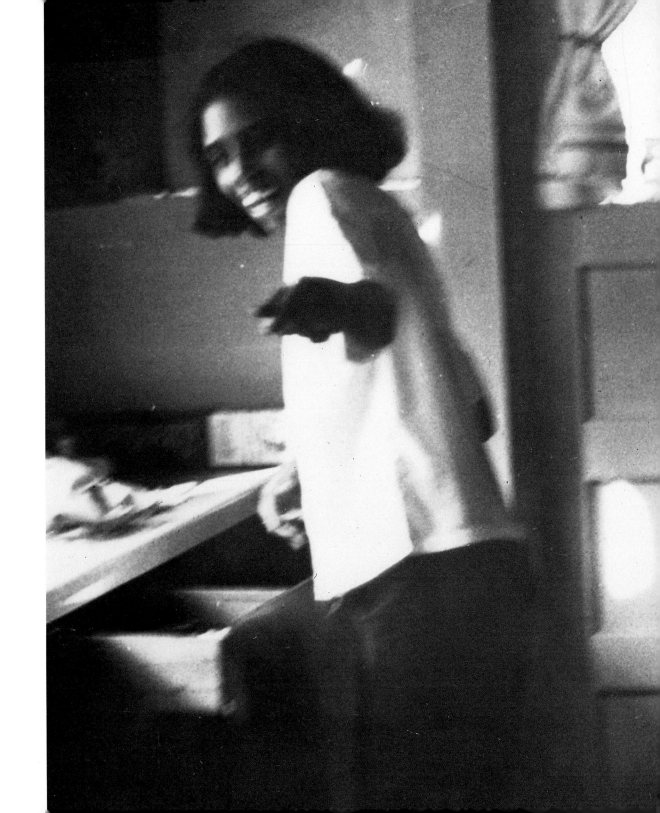

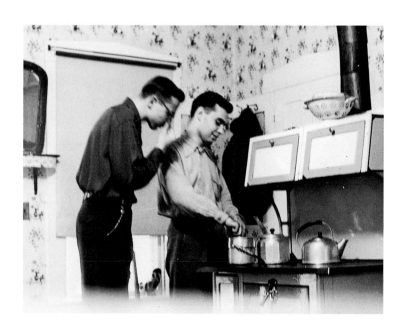

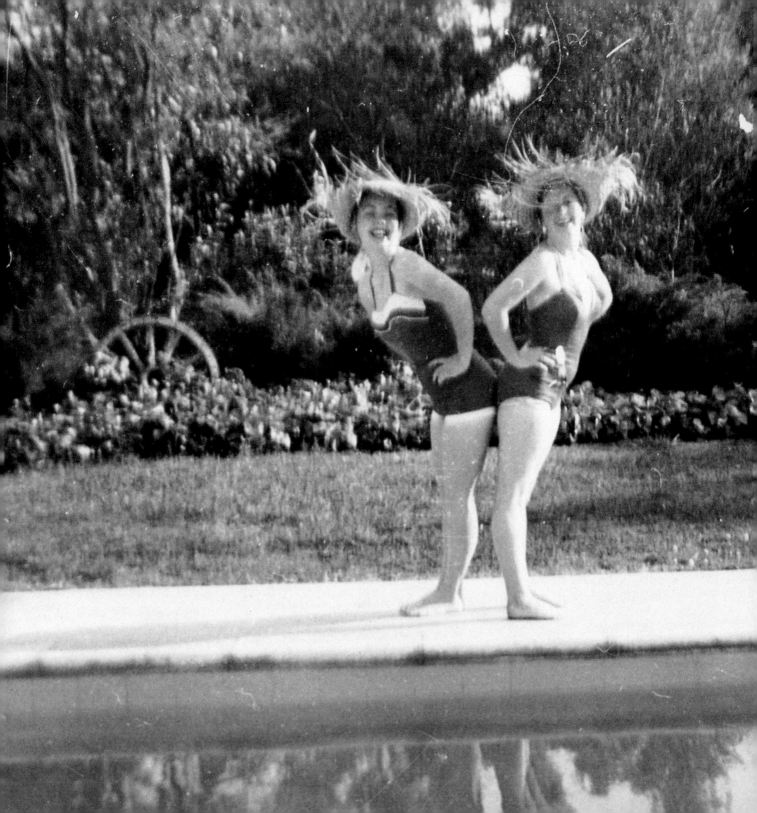

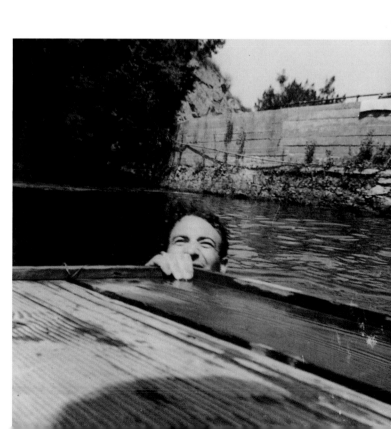

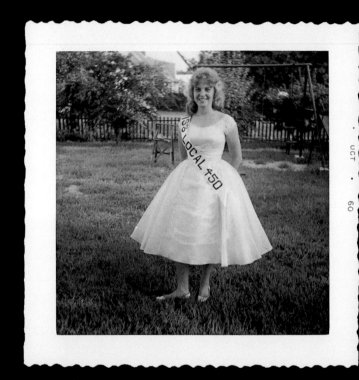

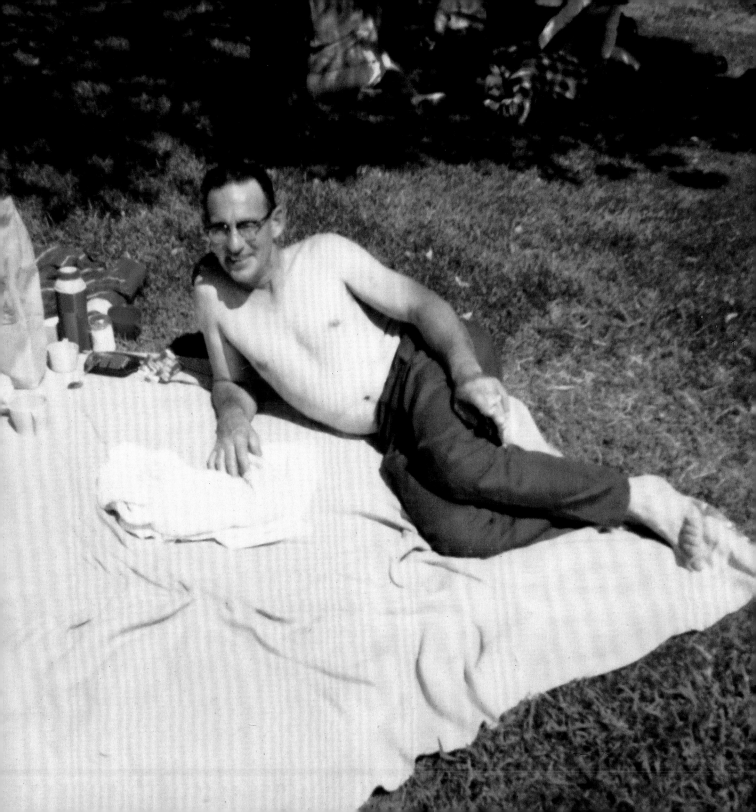

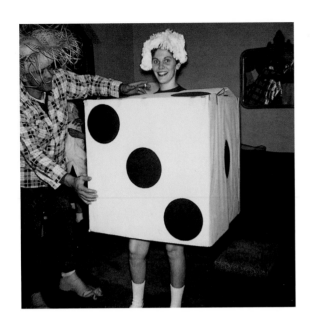

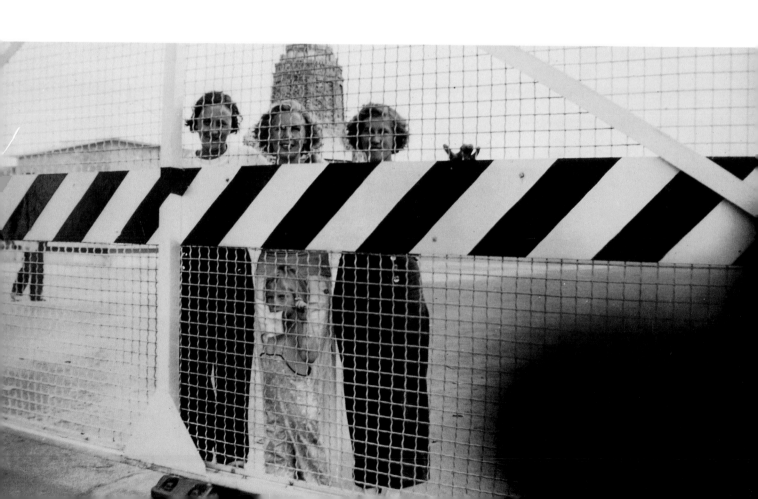

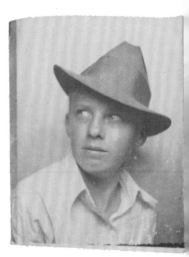
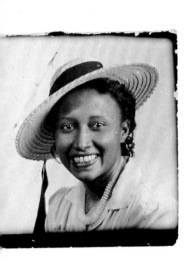
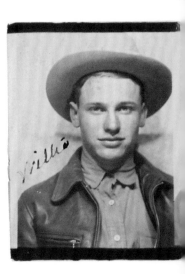
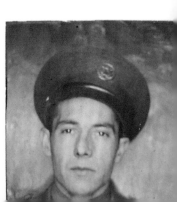

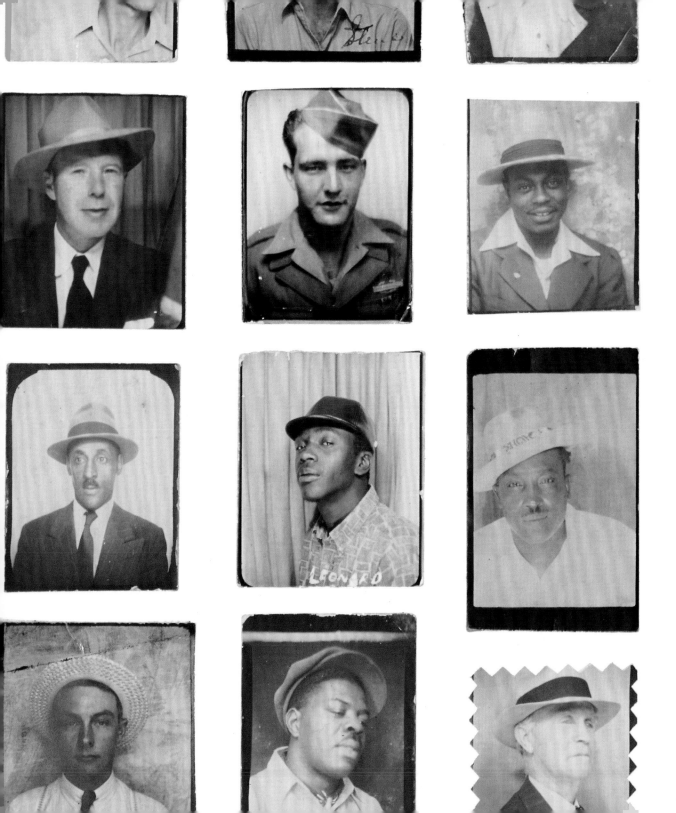

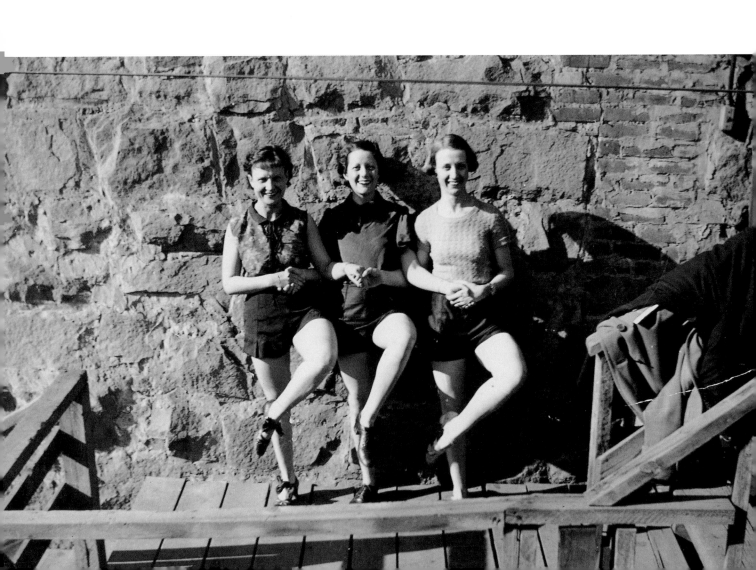

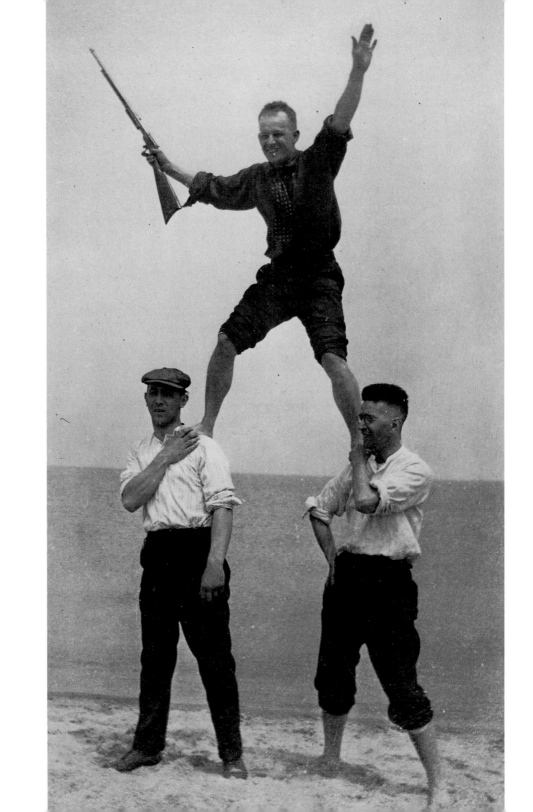

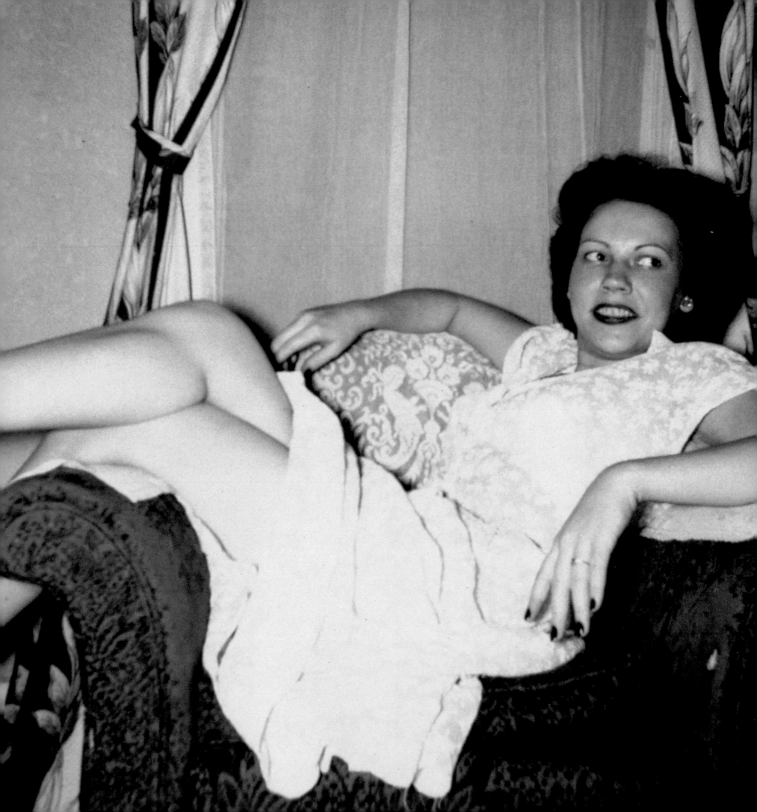

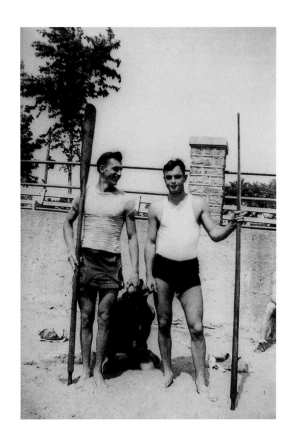

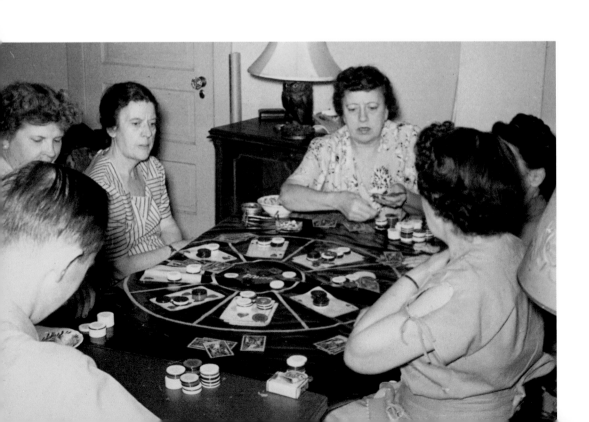

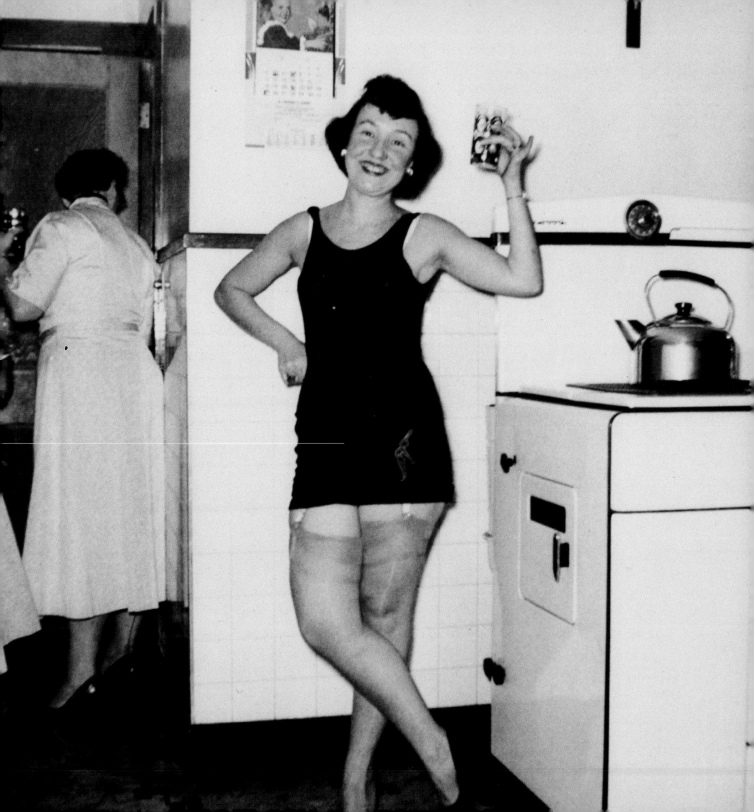

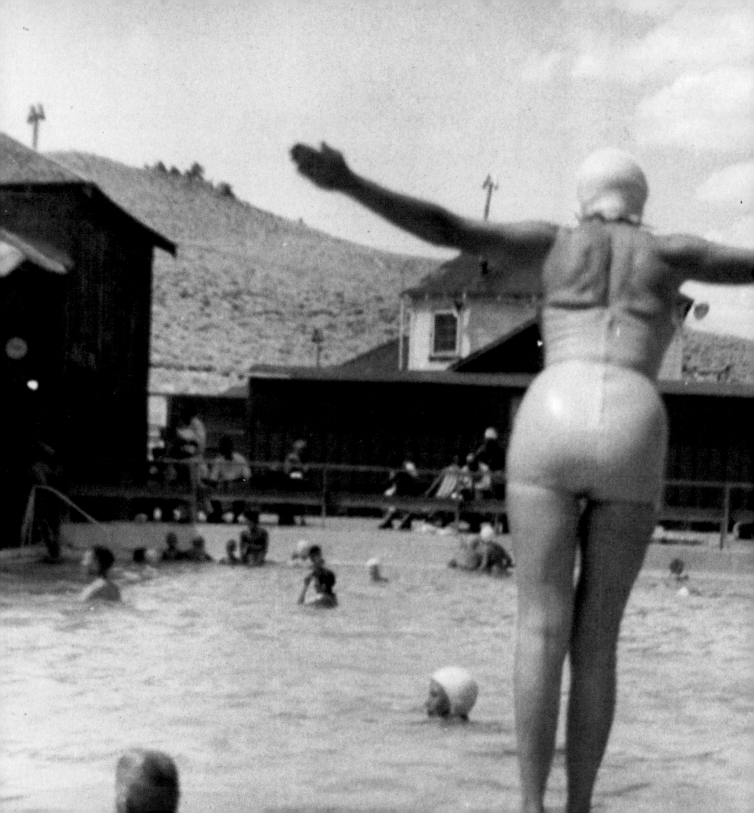

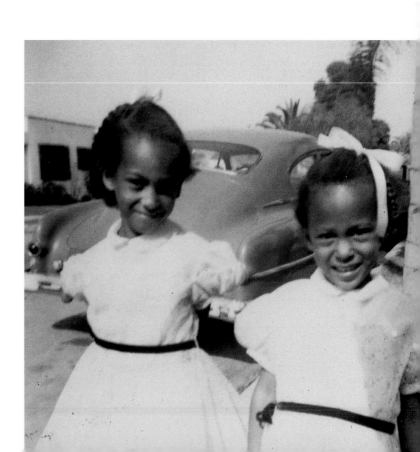

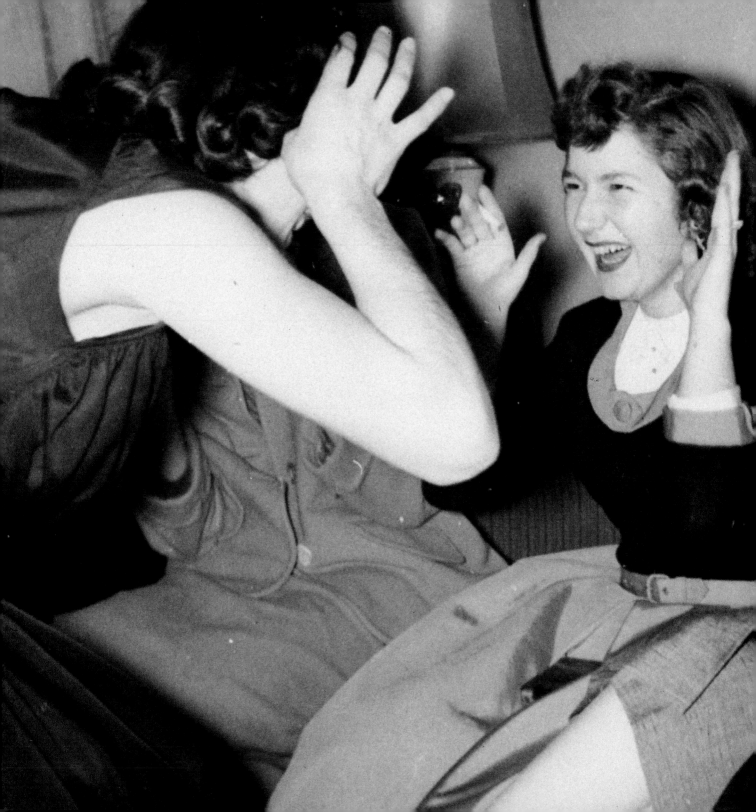

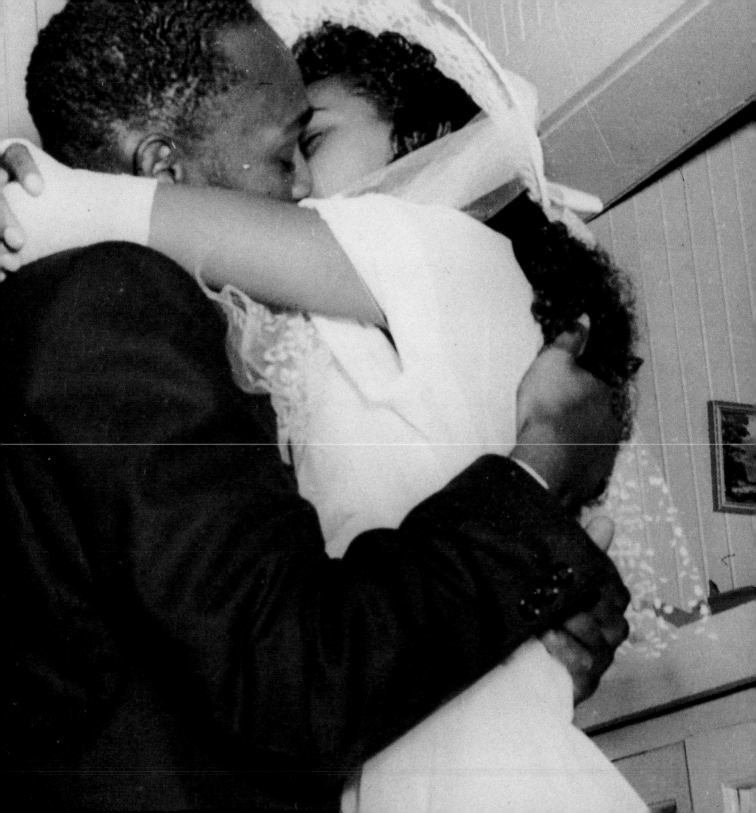

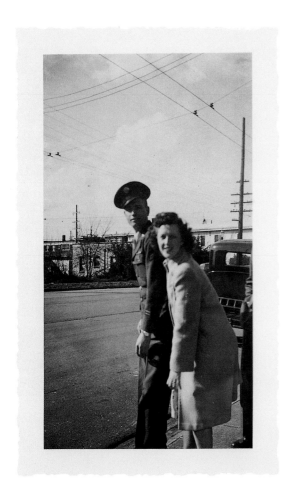

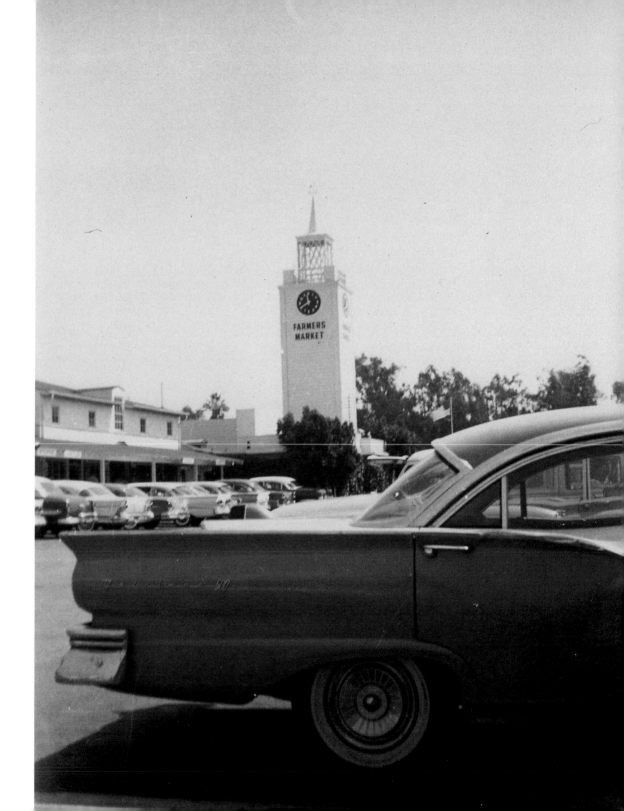

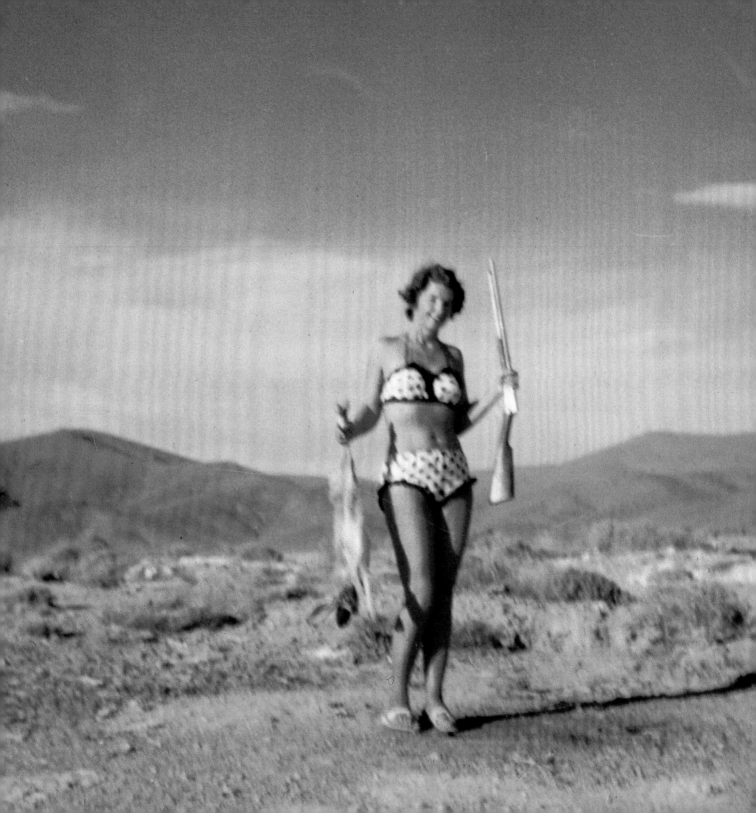

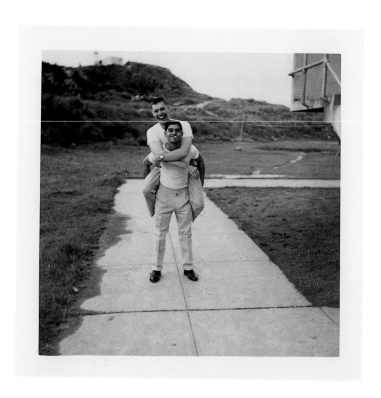

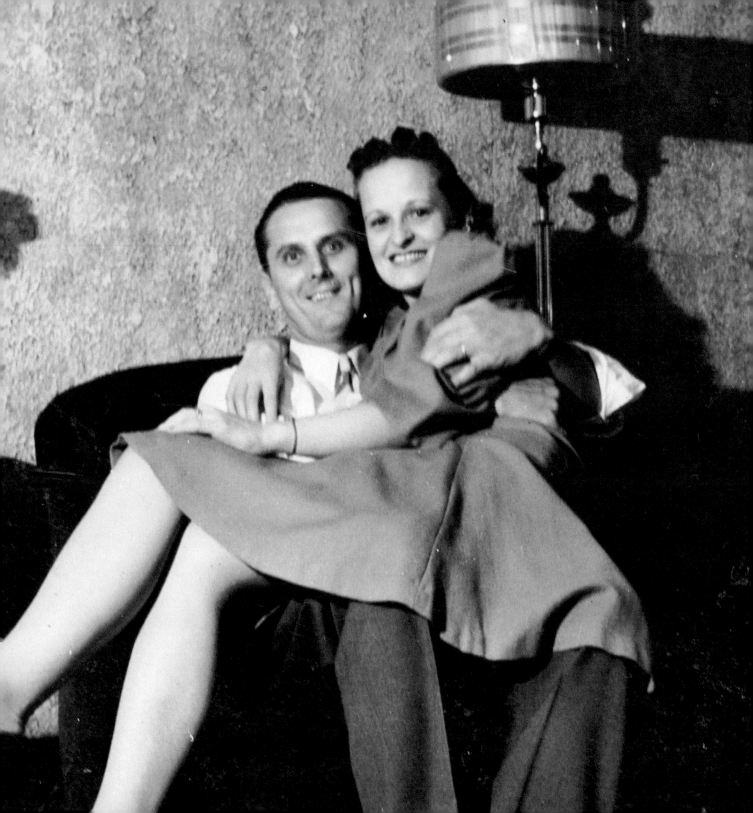

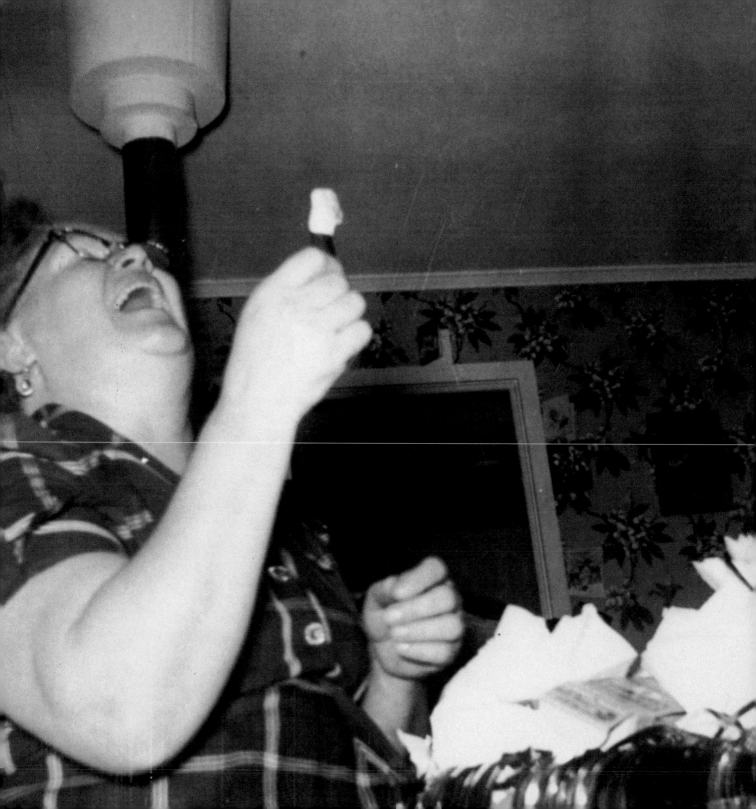

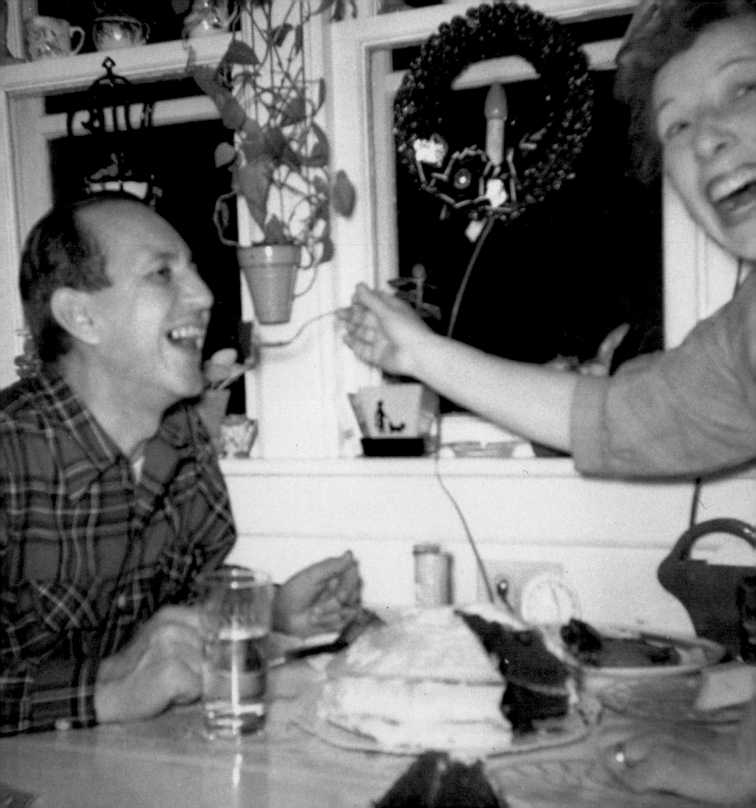

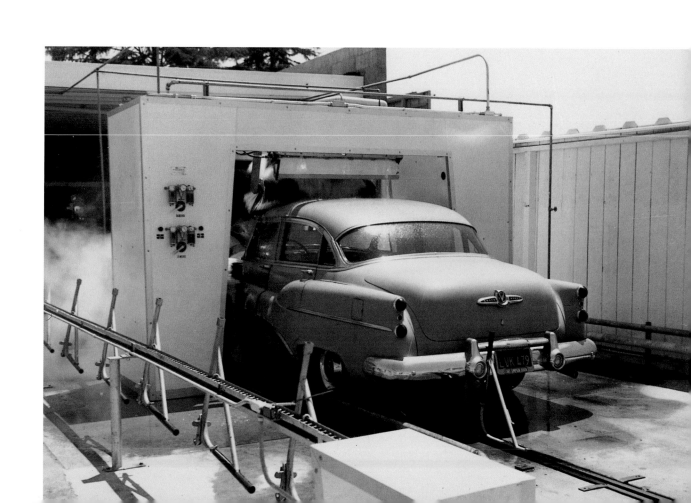

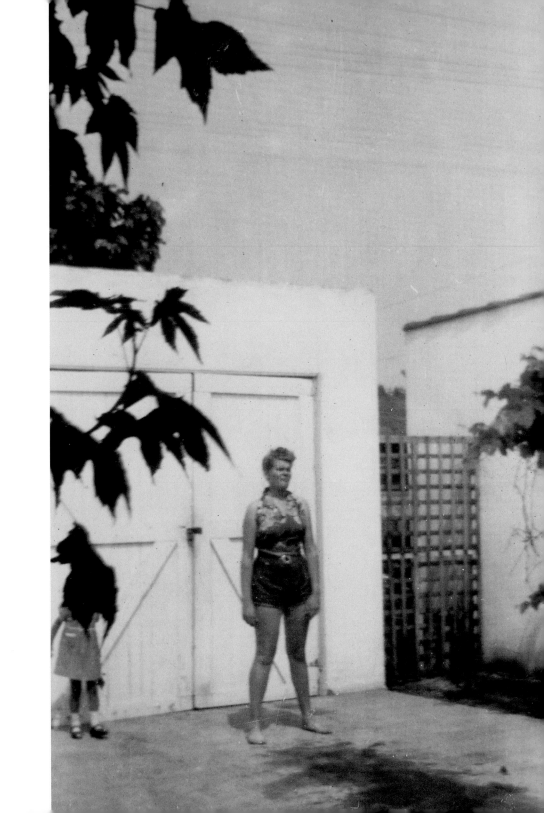

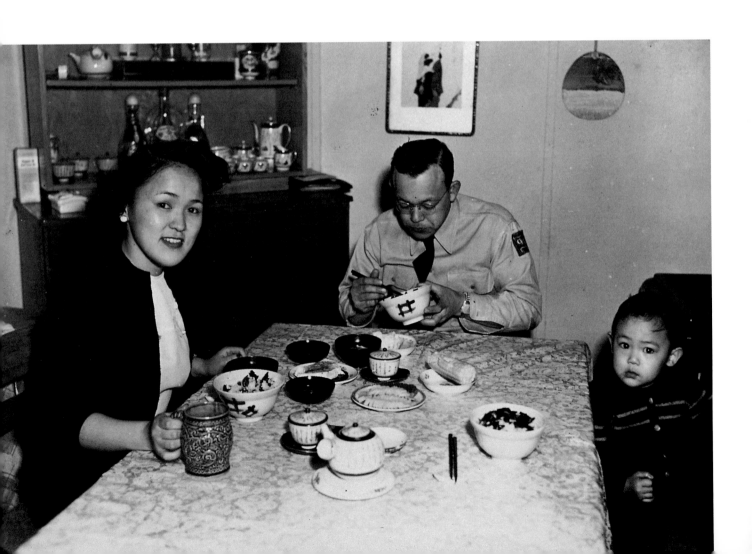

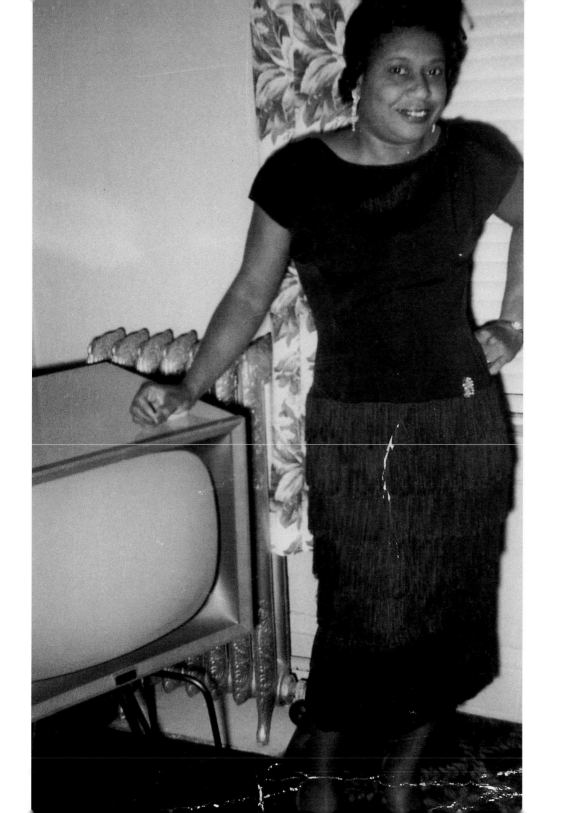

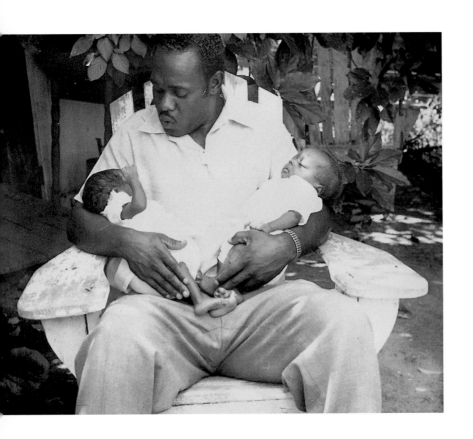

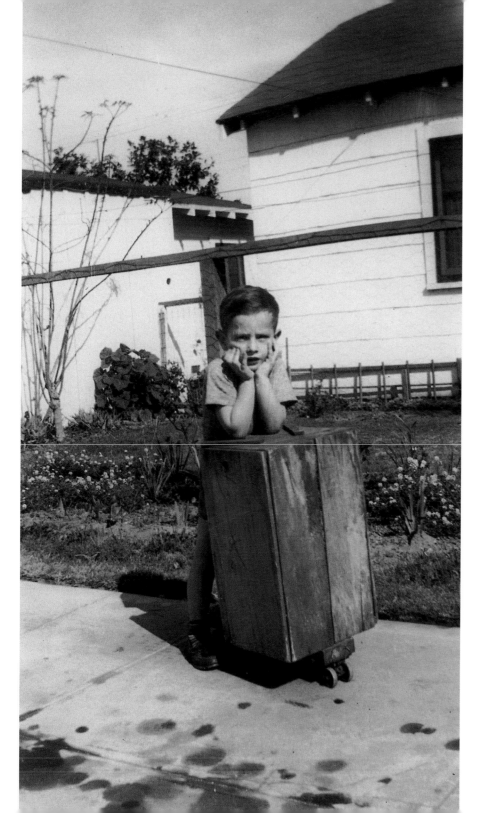

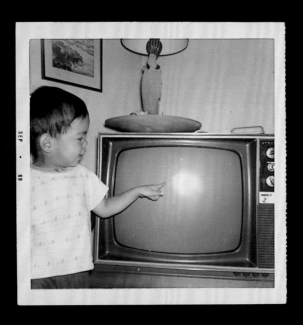

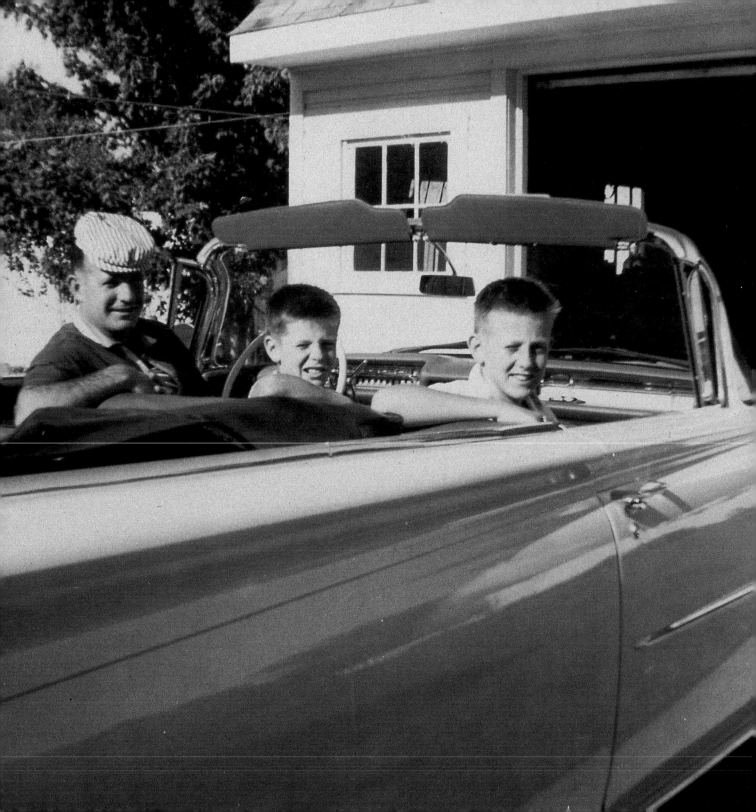

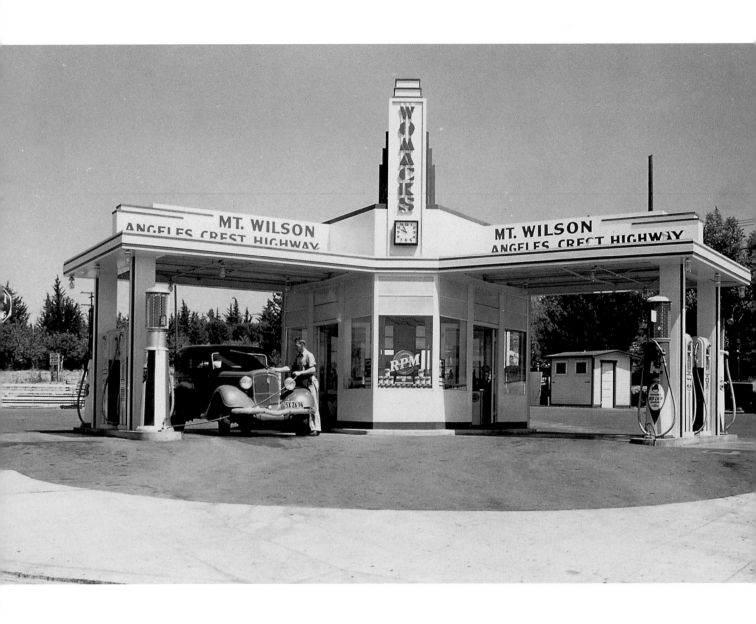

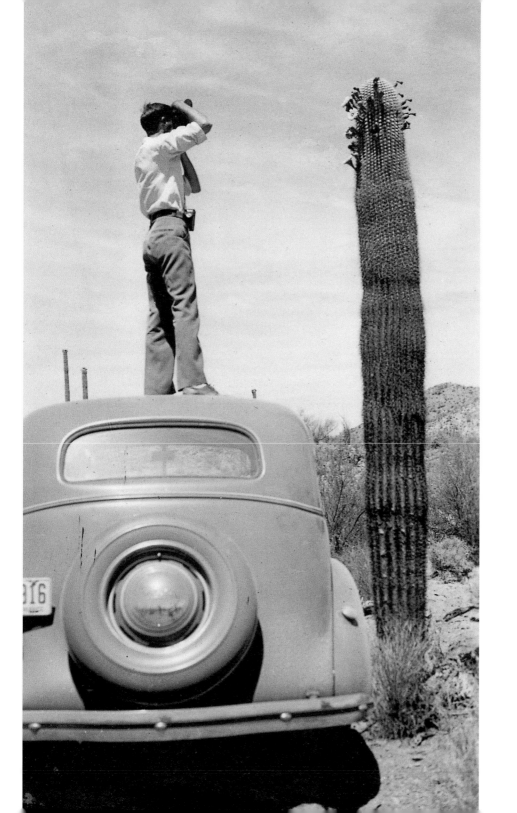

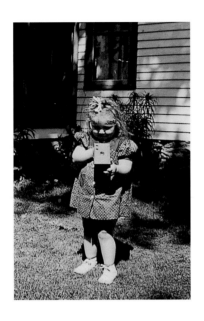

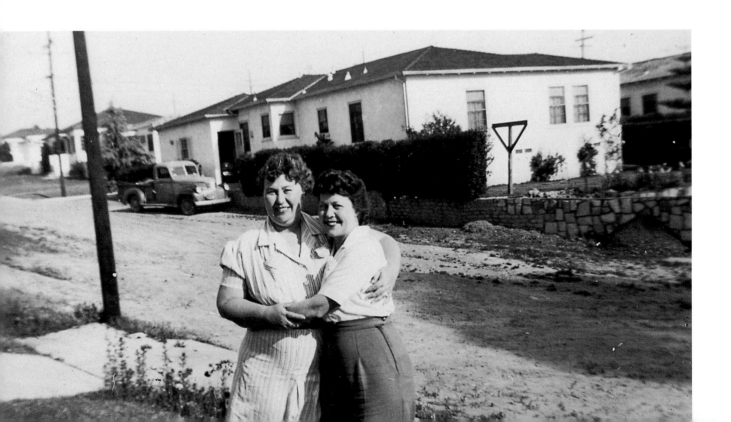

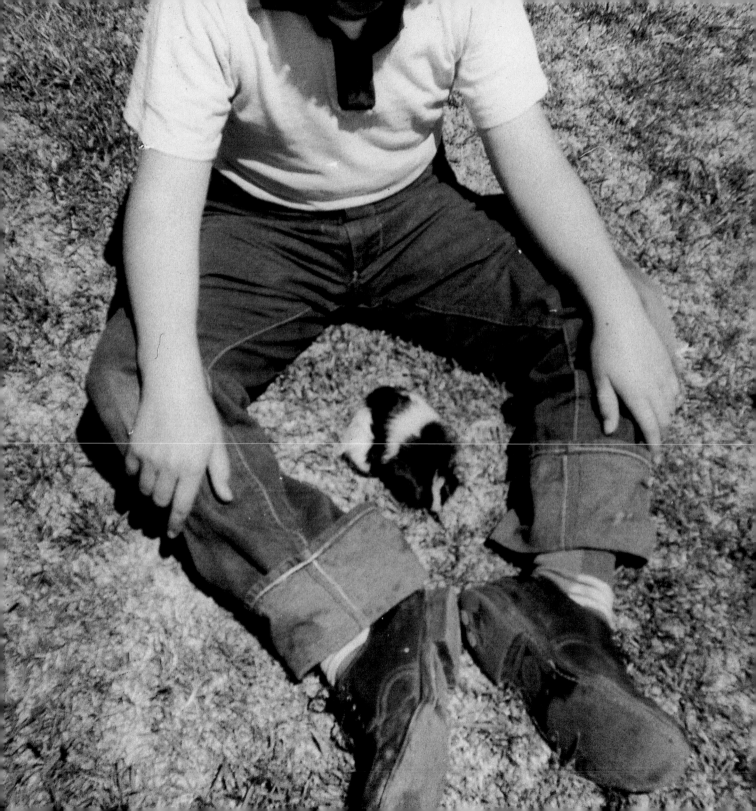

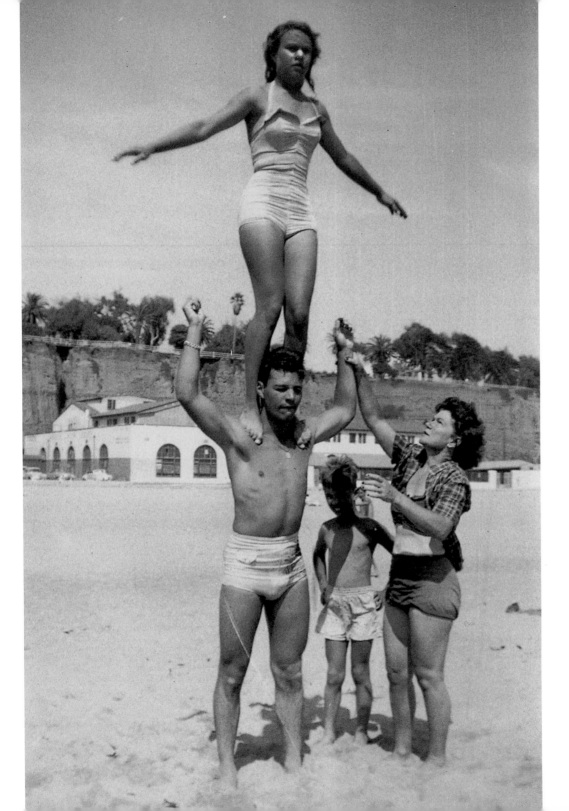

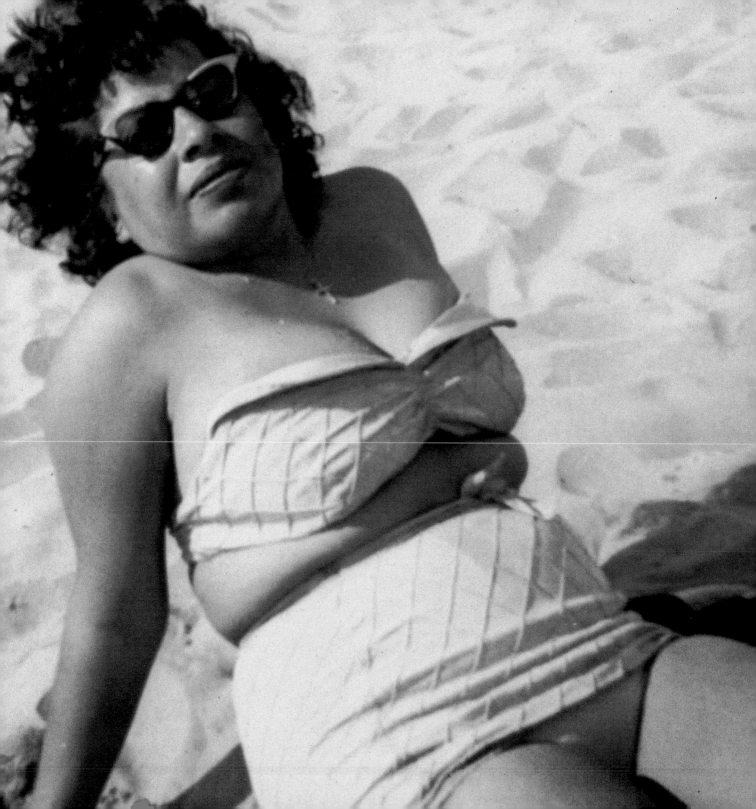

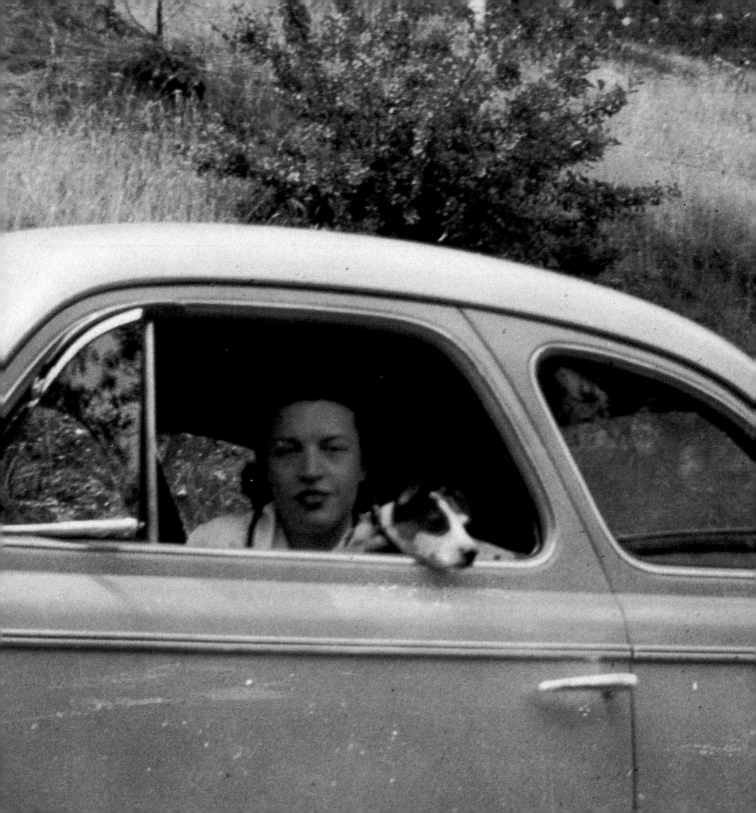

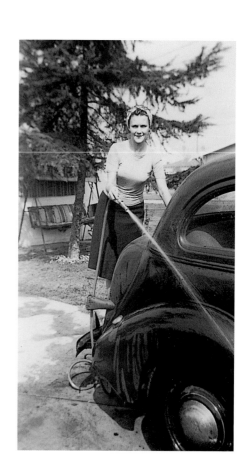

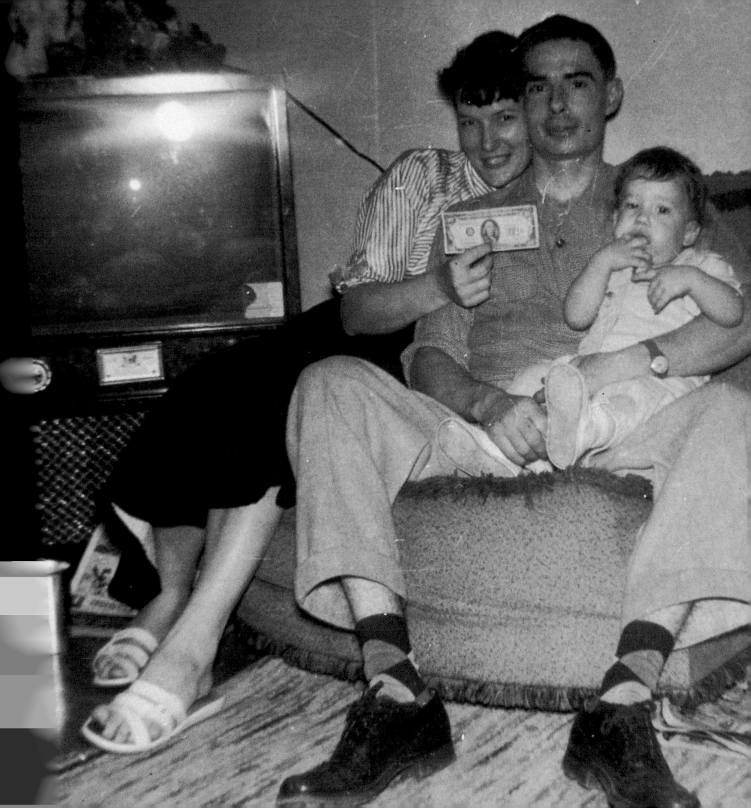

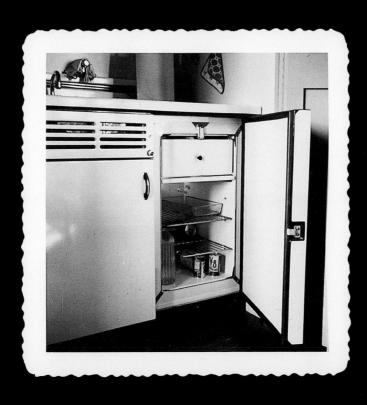

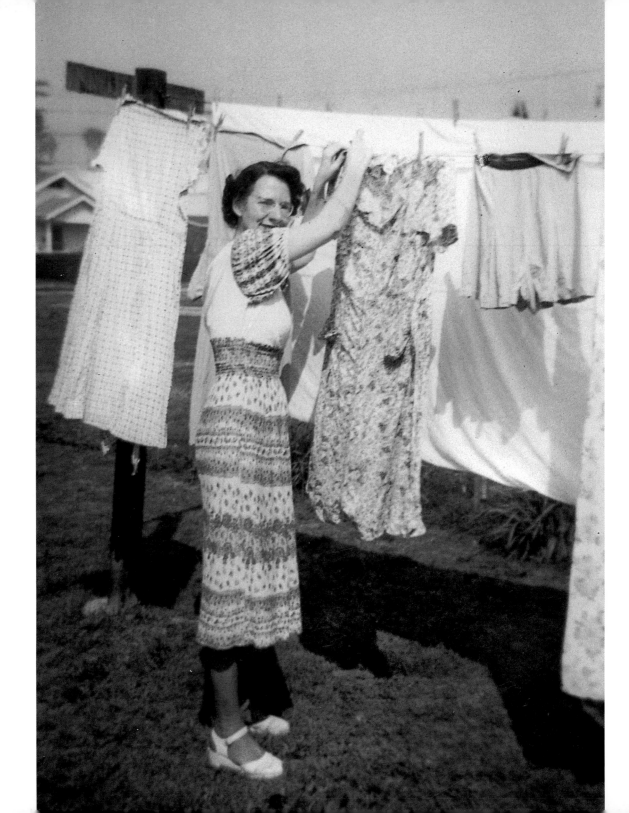

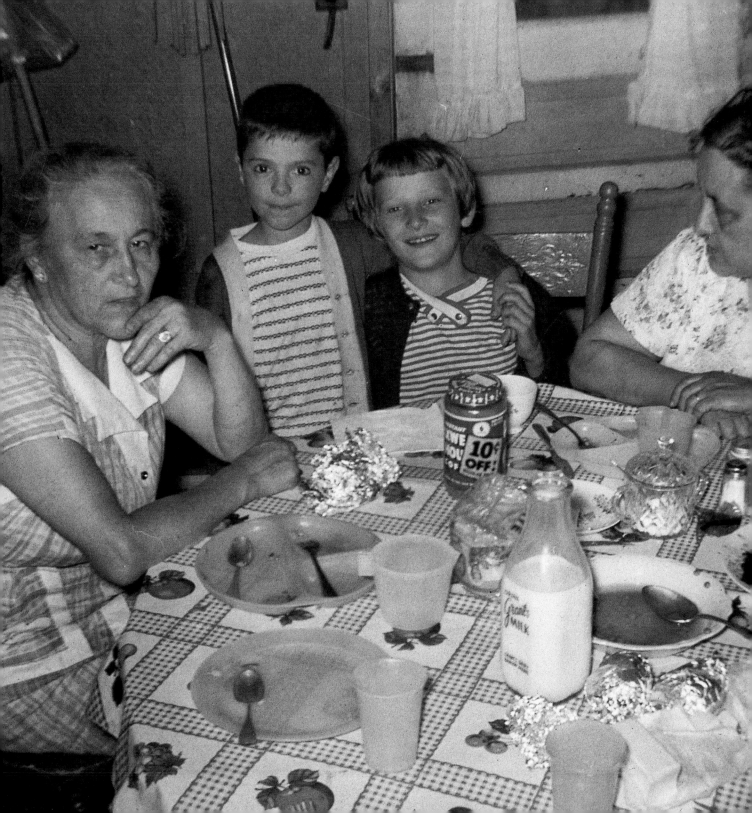

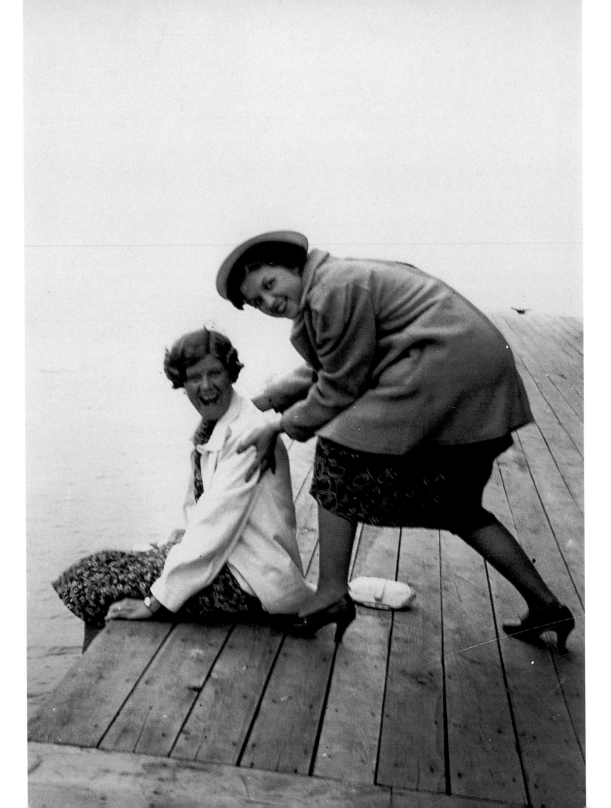

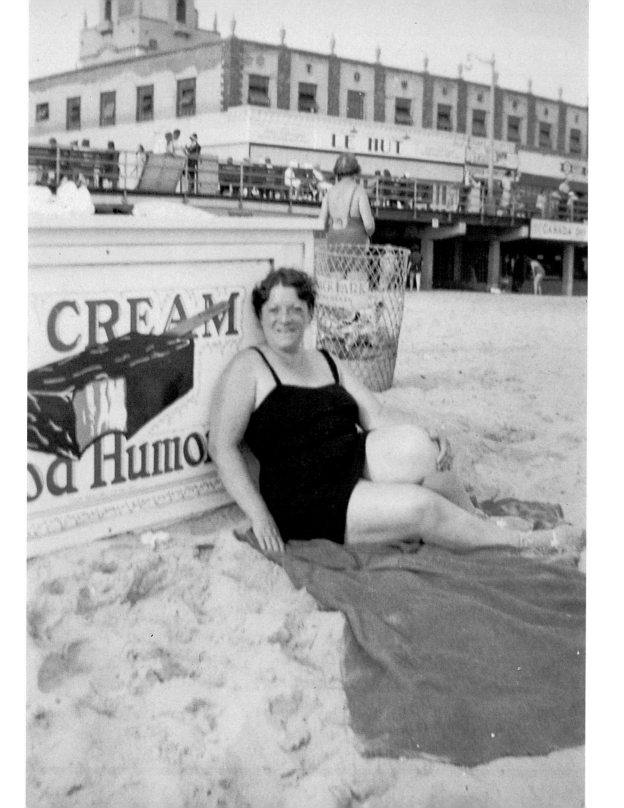

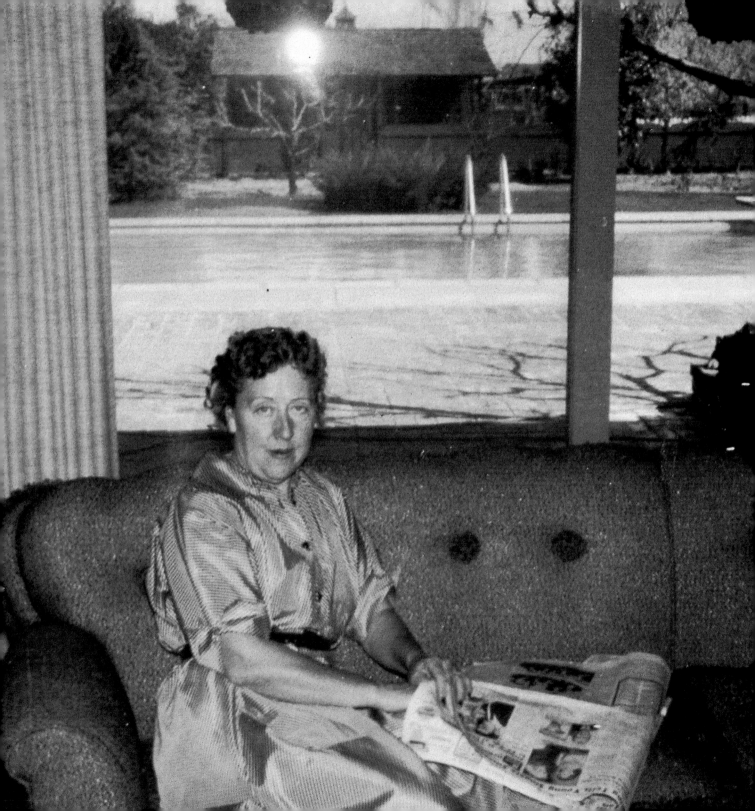

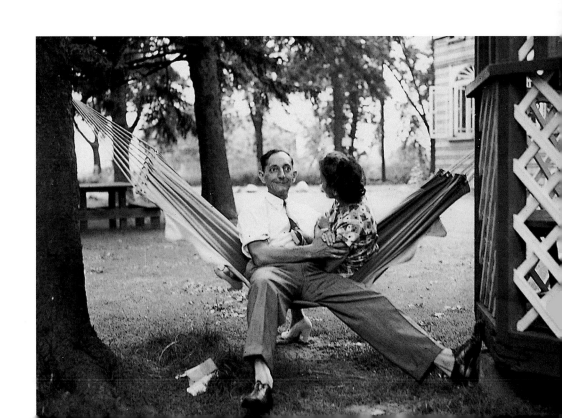

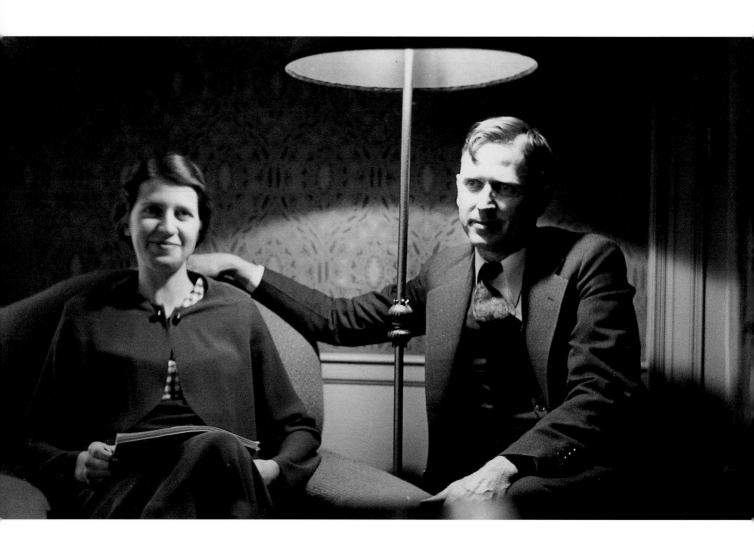

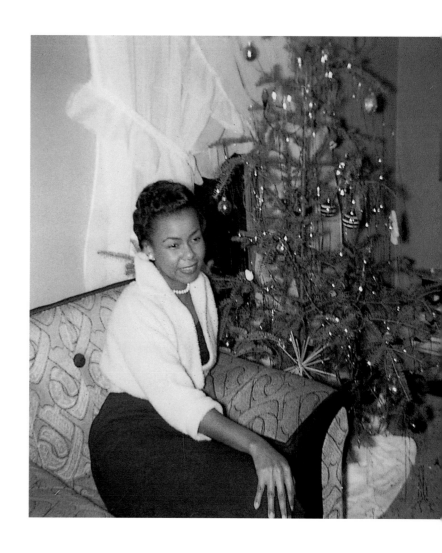

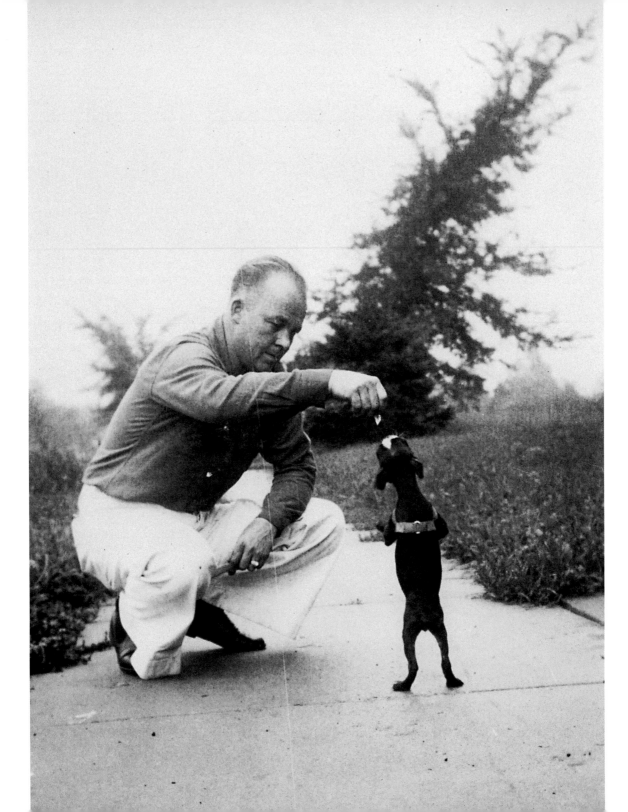

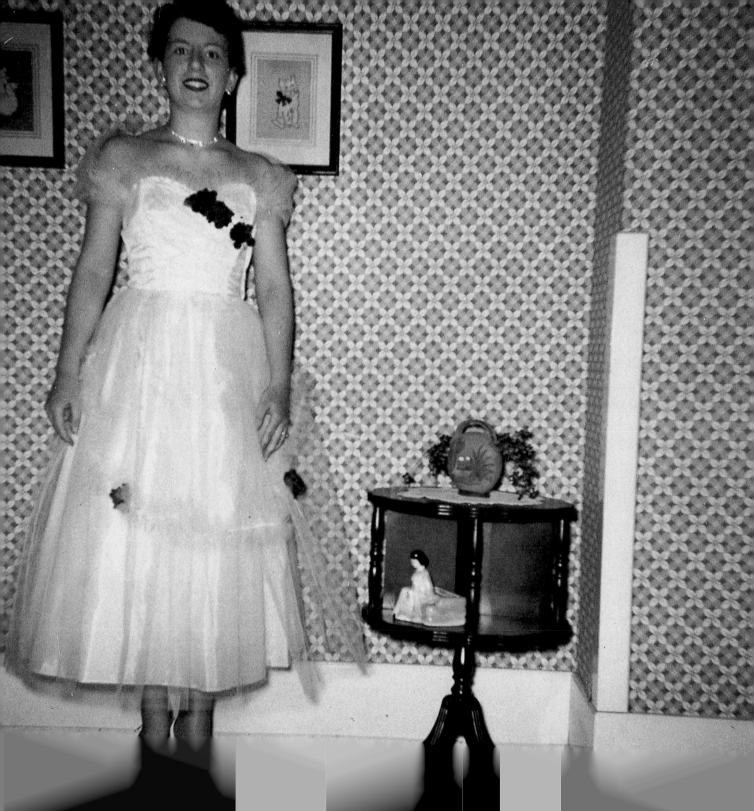

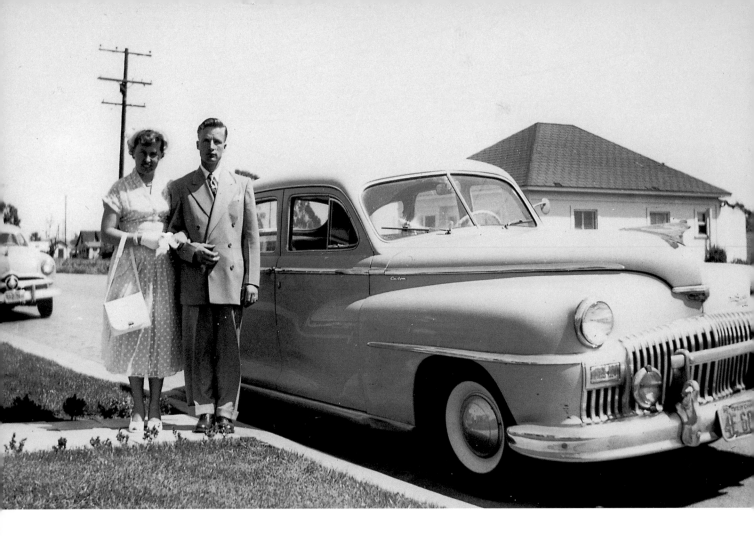

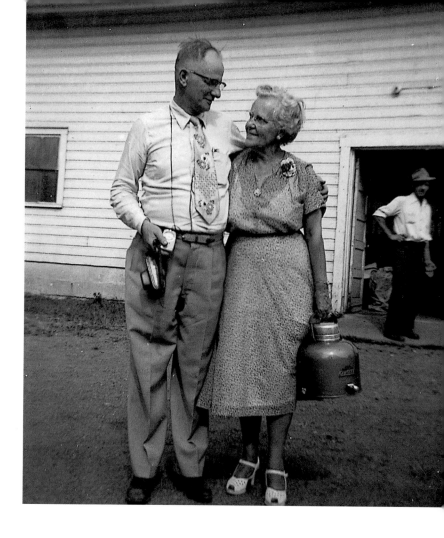

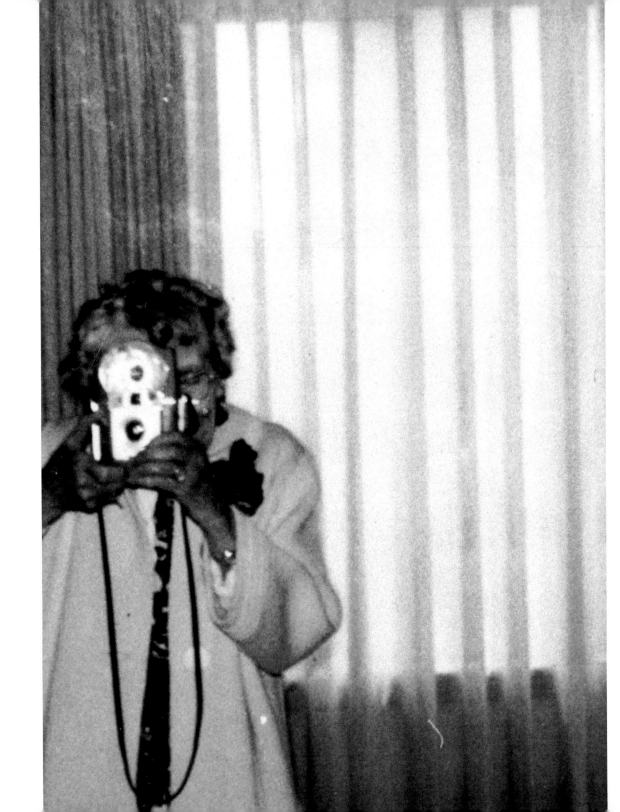

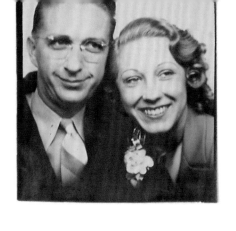
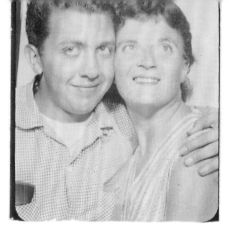
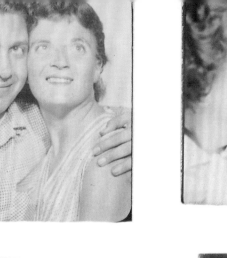
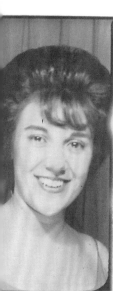
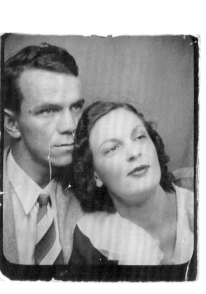
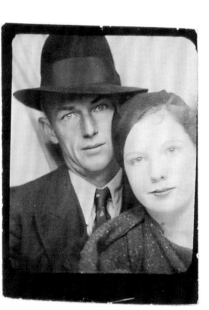
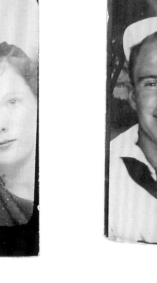

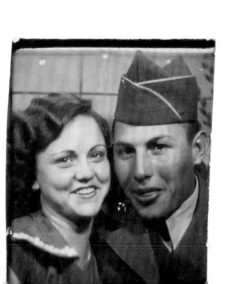
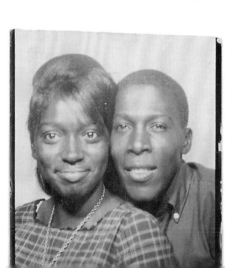

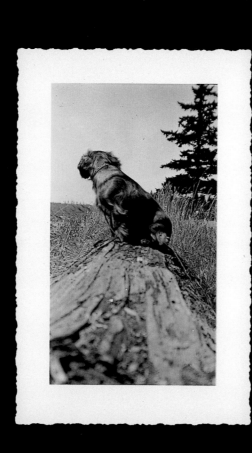

INSPIRED BY A KODACHROME PHOTOGRAPH of his family taken in 1952, Guy Stricherz and his wife, Irene Malli, embarked on a seventeen-year search for Kodachrome transparencies made between 1945 and 1965. Joined by their friend Marianne McCarthy, they issued a call for Kodachrome slides that was mailed to hundreds of small-town newspapers across the country. In response they received more than one hundred thousand color transparencies. From these they selected just ninety-two in which strong color plays a key role. In contrast to the other images in this book, almost all of the makers and the circumstances of these snapshots are known, and this information appears on page 118.

The transparencies were turned into sixteen-by-twenty-inch dye transfer prints that capture the daily lives of ordinary Americans in the post–World War II era. In Guy Stricherz's words: "Each picture has a private meaning, yet each holds a truth common to us all."

Weston Naef

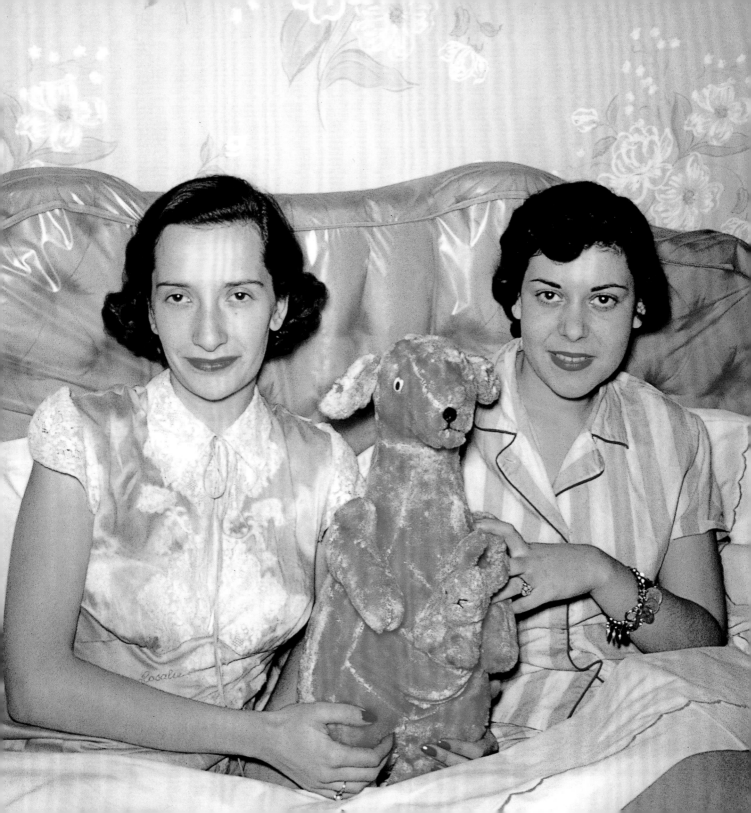

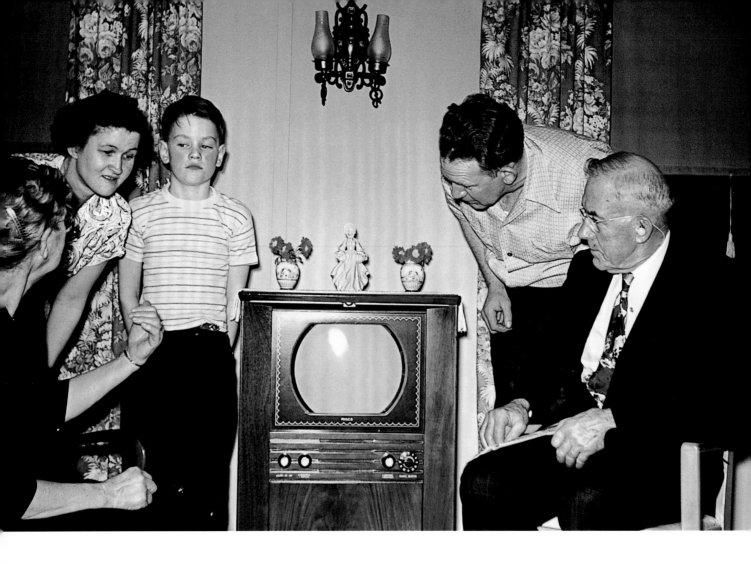

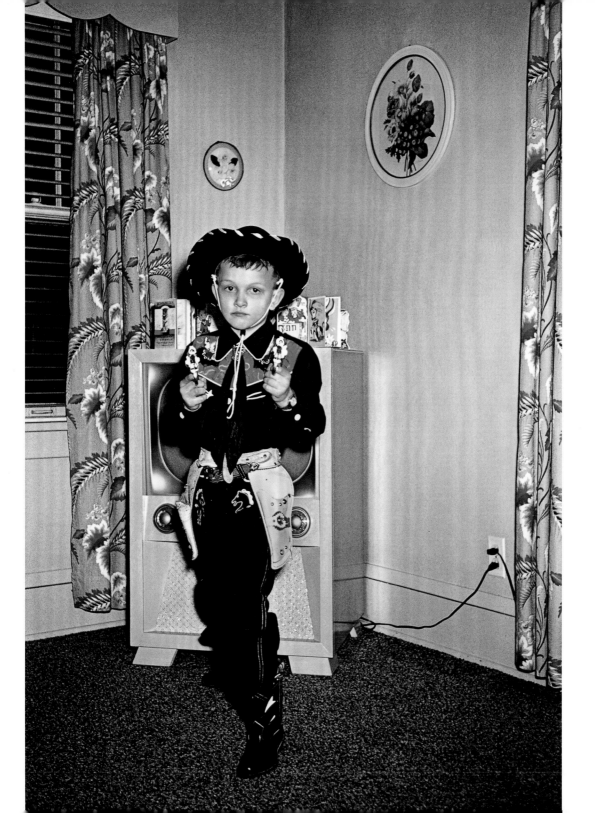

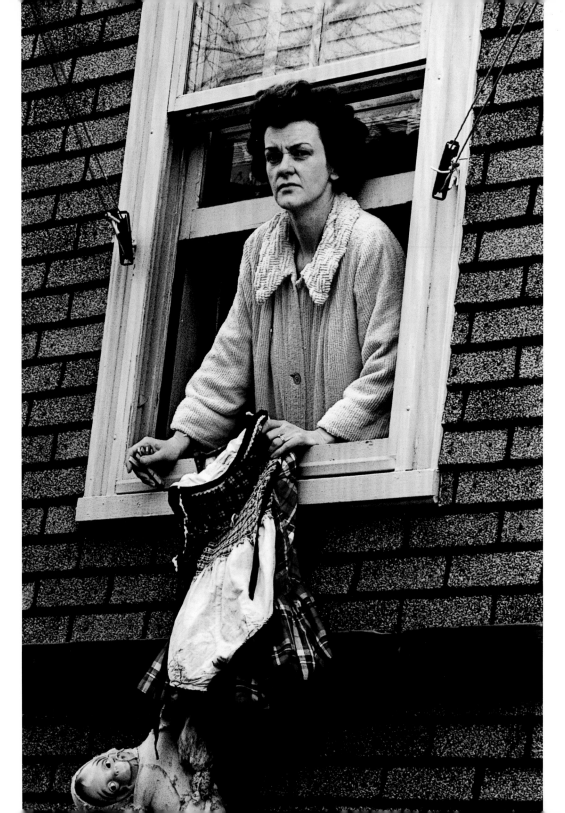

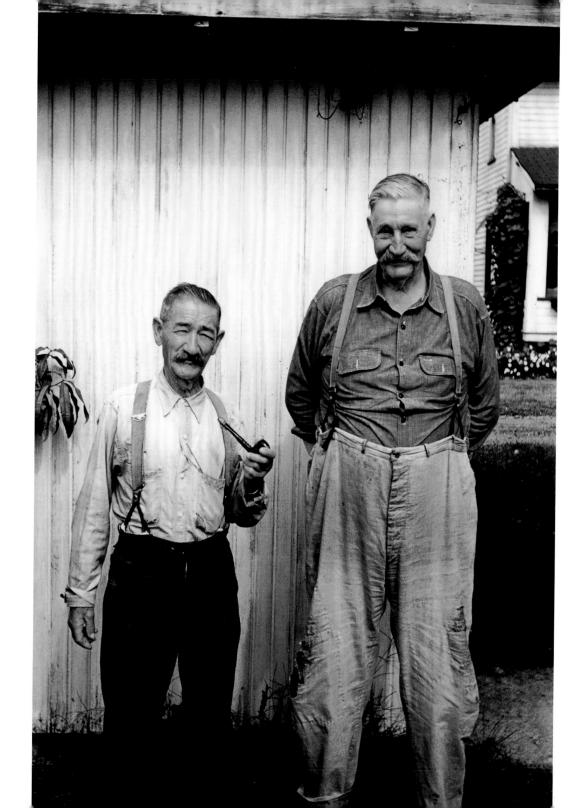

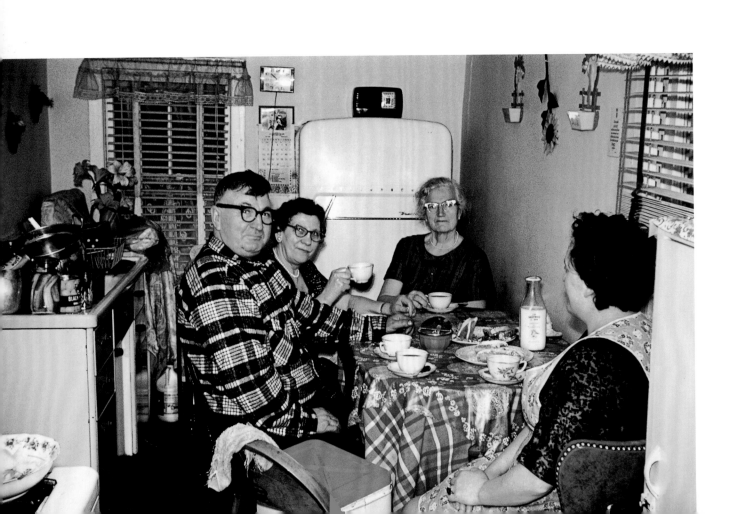

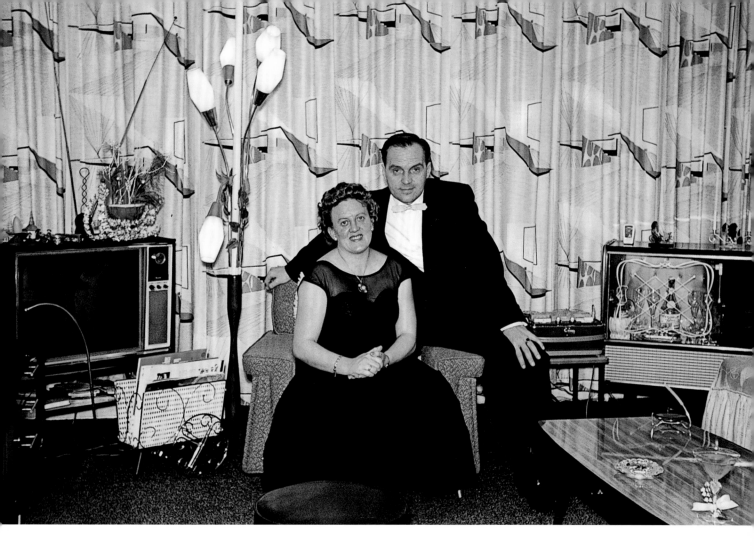

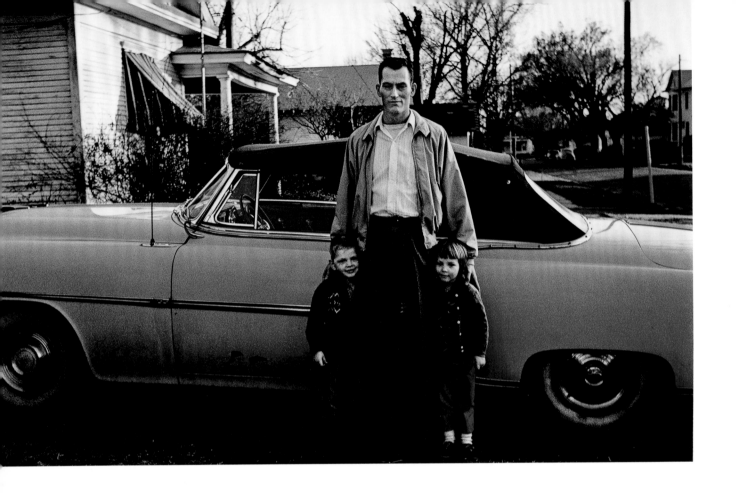

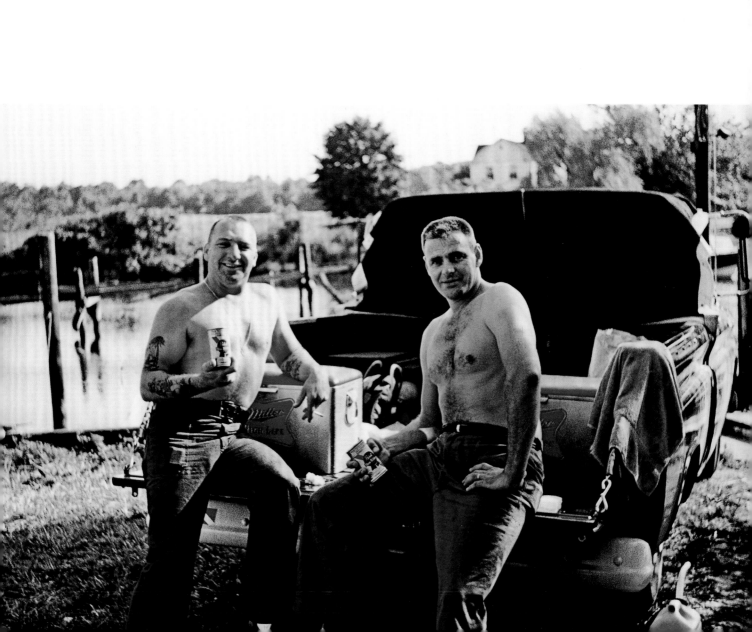

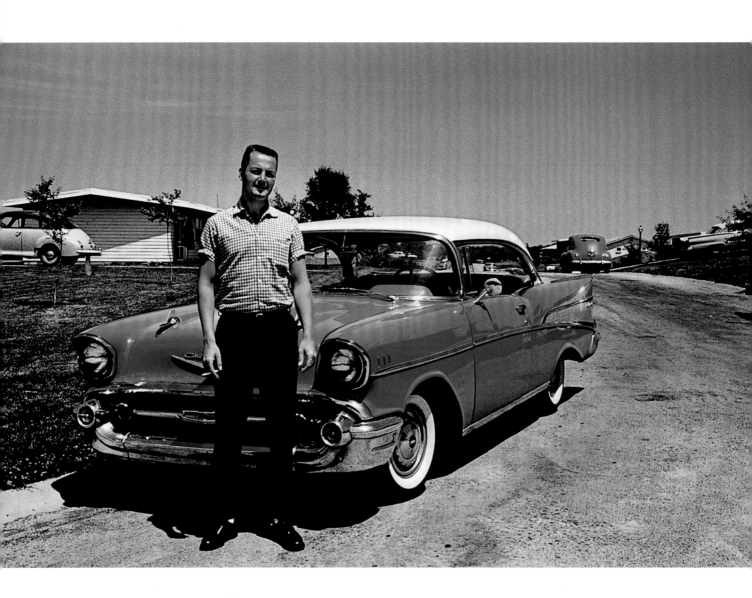

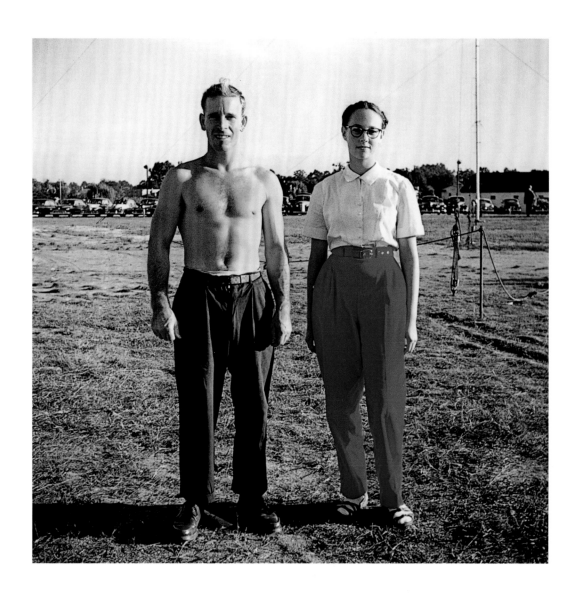

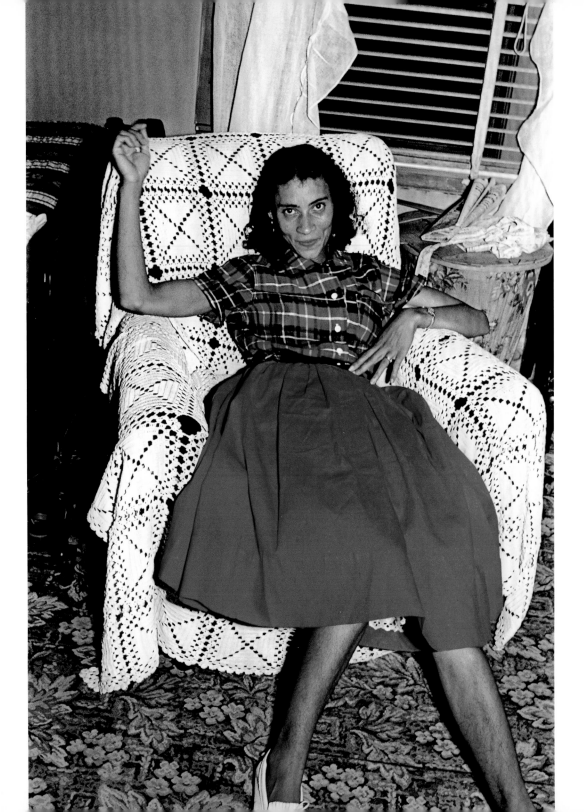

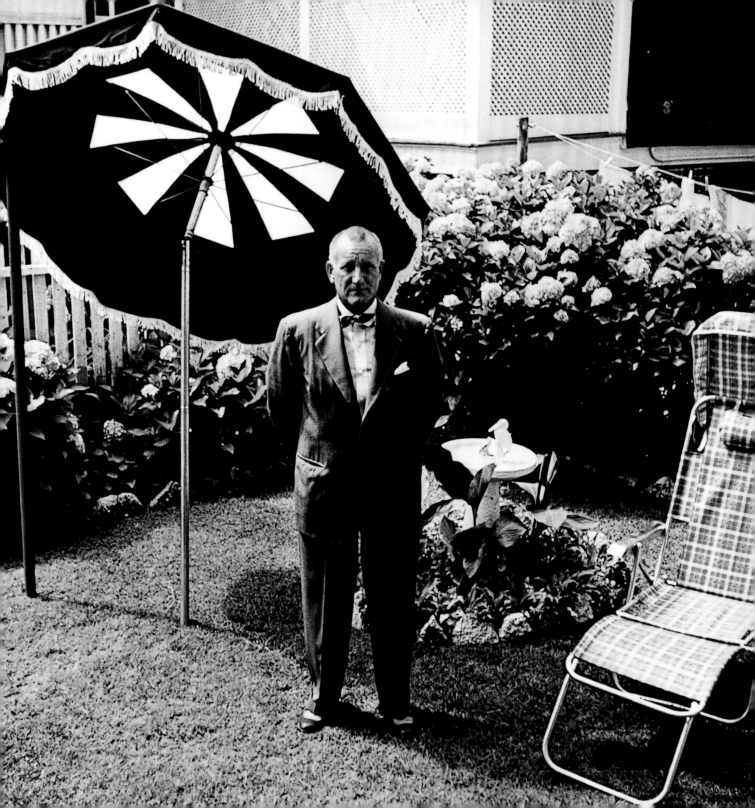

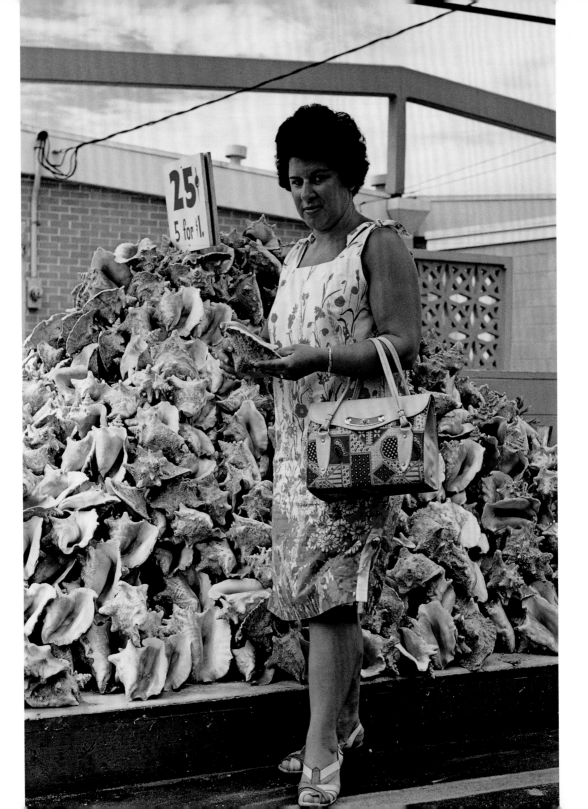

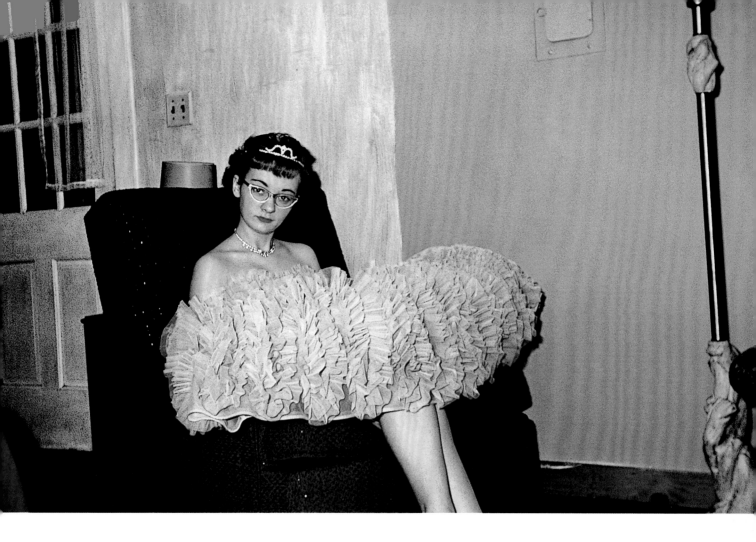

Photographs on pages 1–101: promised gift of Sharon and Michael Blasgen and of Jane and Michael Wilson.

Photographs on pages 103–117: promised gift of Nancy and Bruce Berman.

Page 103 and back cover
Rosalie Julian and Connie Markoff, Brookline, Massachusetts, 1951
Photographer: P. Fredric Julian
L.2003.88.28

Page 104
The Hull Family, Port Byron, Illinois, 1950
Photographer: Leota Hull
L.2003.88.8

Page 105
Daniel Hollenhorst, Age Seven, St. Cloud, Minnesota, 1955
Photographer: Mel Hollenhorst
L.2003.88.30

Page 106
Margaret Conroy, Lynn, Massachusetts, 1963
Photographer: Walter F. Conroy
L.2003.88.7

Page 107
"Mutt and Jeff," Princeton, Illinois, 1951
Photographer: Charles Fawcett
L.2003.88.51

Page 108
Table Scene, 1962
Unknown photographer
L.2003.88.47

Page 109
Couple with Cocktail, 1962
Unknown photographer
L.2003.88.40

Page 110
1954 Pontiac, Muskogee, Oklahoma, 1963
Photographer: Evelyn Gladd
L.2003.88.11

Page 111
Bunker Hill Diving Club, near the Severn River, Maryland, 1962
Photographer: Bill Rowles
L.2003.88.17

Page 112
Jerry Cox, Kansas City, Kansas, about 1962
Photographer: Don Cox
L.2003.88.58

Page 113
County Fair Performers, Catawba County, North Carolina, 1952
Photographer: Tom L. Ciley
L.2003.88.45

Page 114
Tossie Mae Gaston Reynolds, Pilot Rock, North Carolina, 1947
Photographer: Baxter Lovell
L.2003.88.52

Page 115
Al Lockett, July 29, 1965
Unknown photographer
L.2003.88.18

Page 116
Ann Schiavo, Miami Beach, Florida, 1963
Photographer: Emil J. Schiavo Sr.
L.2003.88.32

Page 117
Beverly Gill, Hamilton, Massachusetts, 1961
Photographer: Richard G. Gill
L.2003.88.91

Loan numbers above are from the J. Paul Getty Museum, Los Angeles.

© 2004 J. Paul Getty Trust

Photographs on pages 103–117 © Guy Stricherz

This publication is issued in conjunction with the exhibition *Close to Home: An American Album*, held at the J. Paul Getty Museum, October 12, 2004– January 16, 2005.

Getty Publications
1200 Getty Center Drive
Suite 500
Los Angeles, California 90049-1682
www.getty.edu

Christopher Hudson, Publisher
Mark Greenberg, Editor in Chief

John Harris, Editor
Markus Brilling, Designer
Amita Molloy, Production Coordinator
Christopher Allen Foster, Photographer

Typesetting by Diane Franco
Printed by Graphicom, Vicenza, Italy

Library of Congress Cataloging-in-Publication Data

Close to home : an American album / with an essay by D. J. Waldie.
 p. cm.
ISBN 0-89236-771-7 (pbk.)
1. Photography, Artistic--Exhibitions. I. Waldie, D. J. II. J. Paul Getty Museum.
TR645.L72J223 2004
779'.9973--dc22
 2004007906

Excerpt on page 6 from "Travel Elegy" from *View with a Grain of Sand*, copyright © 1993 by Wislawa Szymborksa. English translation by Stanislaw Baranczak and Clare Cavanagh copyright © 1995 by Harcourt, Inc., reprinted by permission of the publisher.

Excerpt on page 10 from "Any Case" by Wislawa Szymborska. Published in "Selected Poems" in *Quarterly Review of Literature* XXIII (1993), Poetry Series IV. Translated by Sharon Olds, Grazyna Drabik, and Austin Flint.

Excerpt on page 15 from "Memory at Last" by Wislawa Szymborska. Published in *Sounds, Feelings, Thoughts: Seventy Poems by Wislawa Szymborska*. Translated and introduced by Magnus J. Krynski and Robert A. Maguire. Princeton University Press, 1981.

Excerpt on page 15 from Robert Lowell, "Epilogue." Published in *Day by Day*. Farrar, Straus and Giroux, 1978.